THE STUFF GAMES
ARE MADE OF

Playful Thinking

Jesper Juul, Geoffrey Long, William Uricchio, and Mia Consalvo, editors

THE STUFF GAMES ARE MADE OF

PIPPIN BARR

The MIT Press
Cambridge, Massachusetts
London, England

The MIT Press would like to thank the anonymous peer reviewers who provided comments on drafts of this book. The generous work of academic experts is essential for establishing the authority and quality of our publications. We acknowledge with gratitude the contributions of these otherwise uncredited readers.

All images are courtesy of the author unless stated otherwise.

This book was set in Stone Serif and Stone Sans by Jen Jackowitz. Printed and bound in the United States of America.

Library of Congress Cataloging-in-Publication Data

Names: Barr, Pippin, 1979– author.
Title: The stuff games are made of / Pippin Barr.
Description: Cambridge, Massachusetts : The MIT Press, [2023] |
Series: Playful thinking | Includes bibliographical references and
 index.
Identifiers: LCCN 2022034629 (print) | LCCN 2022034630 (ebook) |
 ISBN 9780262546119 (paperback) | ISBN 9780262375108 (epub) |
 ISBN 9780262375115 (pdf)
Subjects: LCSH: Video games—Design, | Video games—Design—Case
 studies.
Classification: LCC GV1469.3 .B38 2023 (print) | LCC GV1469.3
 (ebook) |
DDC 794.8/3—dc23/eng/20220830
LC record available at https://lccn.loc.gov/2022034629
LC ebook record available at https://lccn.loc.gov/2022034630

10 9 8 7 6 5 4 3 2 1

For Felix, who can turn an IKEA sealing clip into a truck, a boot, and an alligator in the space of a minute

CONTENTS

ON THINKING PLAYFULLY

Many people (we series editors included) find video games exhilarating, but it can be just as interesting to ponder why that is so. What do video games do? What can they be used for? How do they work? How do they relate to the rest of the world? Why is play both so important and so powerful?

Playful Thinking is a series of short, readable, and argumentative books that share some playfulness and excitement with the games that they are about. Each book in the series is small enough to fit in a backpack or coat pocket, and combines depth with readability for any reader interested in playing more thoughtfully or thinking more playfully. This includes, but is by no means limited to, academics, game makers, and curious players.

So, we are casting our net wide. Each book in our series provides a blend of new insights and interesting arguments with overviews of knowledge from game studies and other areas. You will see this reflected not just in the range of titles in our series, but in the range of authors creating them. Our basic assumption is simple: video games are such a flourishing

medium that any new perspective on them is likely to show us something unseen or forgotten, including those from such unconventional voices as artists, philosophers, or specialists in other industries or fields of study. These books are bridge builders, cross-pollinating both areas with new knowledge and new ways of thinking.

At its heart, this is what Playful Thinking is all about: new ways of thinking about games and new ways of using games to think about the rest of the world.

Jesper Juul
Geoffrey Long
William Uricchio
Mia Consalvo

ACKNOWLEDGMENTS

This book is the product of at least a decade of making and thinking about video games, so it's a challenge to thank all of the countless people who've had an influence on it in one way or another. Honestly, it's hard not to go all the way back to John Mills, who sold my parents an Apple IIe back in the early '80s, but I'll try to keep this about the book itself.

We wouldn't be here if Jesper Juul and the other Playful Thinking series editors hadn't been up for the project. Their earliest feedback on the proposal was truly formative. Working with Noah Springer and Lillian Dunaj at the MIT Press has been a smooth, professional, and friendly process that I deeply appreciate. Perhaps most of all, the anonymous reviewers who gave their time and intelligent attention to two versions of the book had a far-reaching impact on everything about it; I can't thank them enough, and I don't even know who they are.

The independent games community is and has been close to my heart and mind for a long time now. Conversations (both real and imagined) I've had with designers like Mattie Brice, Michael Brough, Rami Ismail, Liz Ryerson, Robert Yang,

and many others have deeply informed how I think about game design and development. In a similar way, my participation in various judge and jury pools for festivals like the Independent Game Festival or IndieCade has led to insights into the inner workings of the world of games I could never have had otherwise. It's all in this book, in one way or another.

I'm fortunate to work at Concordia University in Montréal, an institution that supports my work from top to bottom. Most of all, I have to thank my colleagues, whether faculty, graduate, or undergraduate, who are part of the Technoculture, Art, and Games Research Centre. That goes triple for the brave and thoughtful Design Conversations group there—you know who you are. I owe a special debt of gratitude to Jonathan Lessard, who works down the hall, has suffered through making multiple games with me, and is a wonderful sounding board for ideas big and small.

My parents, Mary and Jim Barr, have always been my closest and most devoted readers and editors. I shudder to think about the hundreds of thousands (millions?) of my words they've gone through with a fine-toothed comb over the years, suggesting improvements both incremental and profound. I'd be lost as a writer without them.

Finally, Rilla Khaled, my wife *and* colleague, needs her own paragraph. She reads my writing with a critical and supportive eye and solves design problems with the flick of a wrist (you'll see). There's nobody better to have in your corner, but you'll have to find your own special someone, I'm afraid.

1 INTRODUCTION: WHAT IS ALL THIS STUFF?

Imagine a game made purely out of points.

You'd play the game on the scoreboard itself, clicking a plus button next to your score to increase it by a single point each time. You could push down other players in the rankings by clicking a minus button next to their entry. Just a wall of names and scores vying to be number one. The points would be all there was.

Well, I made that game back in 2014. I was interested in the idea of a game literally *about* points rather than other accomplishments like collecting coins, scoring goals, or shooting faces. I called my game *Leaderboarder* (Barr 2014), put it up as a website, told my meager Twitter following about it, and started to play, clicking my plus button as fast as I could.

At first everyone played as I'd envisaged, increasing their own score a click at a time and sometimes decreasing someone else's. Soon, though, things changed. Things got weird. As tens and then hundreds of players joined the fray, the competition became fierce. Fierce and automated. Some players, not content with the finger's pace of their scoring, applied *auto*

clickers—software that can simulate thousands of mouse clicks per second—to the problem. I watched as scores raced up the rankings like performance sports cars.

Then the auto clickers were old news. *Leaderboarder* was written in JavaScript and JavaScript is not a particularly secure programming language. Any player could view the source code quite easily in their web browser, and that is exactly what some of them did. They looked through the program, understood how the scoring system worked, and then ran their own code in the game. Now they could set their score to arbitrary values and go from last to first in an instant. Some players began to covet the lowest score. Some started giving themselves fractional scores. One player named themselves "Nanananananananananana" and gave themselves the score of "BATMAN."

The endgame came when a few enterprising players wrote code that monitored the leaderboard for changes in real time and automatically adjusted their score accordingly. This meant a player could write a simple bot that would increase their score if any other player surpassed it, ensuring they'd stay on top. More than one player had this idea and there were epic battles between automated scoring bots, each flipping in and out of the lead at an outrageous rate. It was something to behold. In a note to myself, I wrote: "O brave new world!"

Leaderboarder ran deeper than I had initially understood. While I had intended to create a game about points, it turned out to also be about web browsers, about JavaScript, about players in conversation with the very stuff games are made of. A video game is not merely the sum of its parts but a far more complex interaction in which every element—platforms and programming languages, rules and raycasting, memory use and music—influences how play unfolds. Each component

part is worthy of contemplation, and that's my guiding principle in this book. *What can we learn when we really pay attention to the stuff of games?*

I mostly chose the title *The Stuff Games Are Made Of* because I like the way it sounds. The term "stuff" is rather hard to pin down, and I don't plan to try. Anthropologist Daniel Miller (2010, 1), who studies diverse cultural uses of everyday objects and who literally wrote a book called *Stuff*, takes the same line. He opens his discussion of the idea with: "don't, just don't, ask for or expect a clear definition of 'stuff'." And yet, as Miller's work emphasizes again and again in studies of key artifacts from diverse countries, it's the stuff all around us—from saris to cellphones—that shapes how we think and live. In India, a sari is foremost an item of clothing, but it can do so much more. It can signal social status or ceremony, can help carry a hot pot or act as a pacifier for a crying baby, can serve as an improvised purse, and the list goes on. All these complex functions require "a continued engagement and conversation with its wearer, and a constant pressure to respond to changes in one's surrounding social environment" (30–31). And as for cellphones, in the Philippines they're the very stuff of life: "a relationship is not really a relationship without between 20 and 120 texts a day." Crucially, Miller points out, this cellphone-based love metric "isn't an inherent capacity [of the cellphone], but then it's not really a Filipino tradition either. It's something new" (112).

In conversation with our stuff, Miller concludes, we invent new habits, traditions, and practices. It's how we have new ideas and figure out new relations and ways of doing things. Video games are made of their own kinds of stuff, and through that stuff we can learn to understand them better. This is exactly what the players of *Leaderboarder* showed us. There

was indeed a Miller-like engagement and conversation going on there that was neither inherent to the game nor the player but rather emerged out of their interaction. There is already a strong tradition of this kind of thinking about media, digital media more specifically. It ranges from the foundational ideas in Marshall McLuhan's (1994) *Understanding Media*, to Edward Tufte's (2004) hyper-specific *The Cognitive Style of PowerPoint*, to Lev Manovich's (2013) broader examination of various forms of media production software in *Software Takes Command*. However, to really get to know the stuff games are made of, we'll need to listen closely to them in particular.

I won't be theorizing video games as media here, though. While I've spent some time playing with theory in my academic career (focusing on triangles for some reason), in this book I'm looking at the stuff games are made of primarily from the perspective of a practitioner—I'm an experimental video game designer and developer. In some sense, I always have been. I grew up with HyperCard in the late 1980s, an exciting tool that allowed you to create animations and link different scenes with buttons. Then I moved on to Macromedia's Director before getting a degree in computer science that let me write my own programs from scratch. Throughout, I've always had an eye for how media, code, and more could combine into playful experiences, whether while attempting to recreate Hamlet in Flash (may it rest in peace) or while getting my computer to sing "Wouldn't It Be Nice" by the Beach Boys. I've stayed on that path—as I write this, I'm making a game about 3D models featured in video games, such as seagulls, supermarkets, and zombies. I'm arranging them into a virtual showcase and inviting players to join me in contemplating them. More on that later.

I'm not alone in my preoccupation with the stuff of games. From in-depth takes on retro gaming hardware (Custodio 2020; Montfort and Bogost 2009), to understanding games via art history (Flanagan 2009; Sharp 2015), to analyses of how video game tools influence game design (Nicoll and Keogh 2019b; Werning 2021), there's a lot of deep thinking out there. In many ways, though, I feel most kinship with what Bonnie Ruberg (2020) has called the "queer games avant-garde" in their interview-based book of the same name. In it, Robert Yang talks lovingly and thoughtfully about a urinal he created for his game *The Tearoom* and Andi McClure speaks of her collaboration with machines and algorithms. Amen.

When I'm designing and developing a video game, I don't follow a straightforward path from an idea ("What if I turned a famous performance art piece into a game?") to a finished work (*The Artist Is Present*). Rather, most of the design work takes place in conversation with stuff. A game programming framework like Phaser trumpets the virtues of making a game based on physics. User interface conventions admonish me to improve the usability of my menu system design. The Unity game engine whispers seductively about the beauty of 3D environments. When you're listening, the stuff games are made of is not quiet, not transparent, and not just there to be used. It's a close companion, offering up its own ideas about game design all along the way.

That experience of deeply engaging with the tools and media I use to make my games is what design theorist Donald Schön (1992) calls a "conversation with materials." I think this gives me permission to use the terms *stuff* and *material* interchangeably for the rest of the book. In Schön's work, the stuff is often that of architecture (steel girders, concrete beams,

physical sites where construction will take place) but it might just as easily be programming languages, 3D models, and game mechanics, because Schön, more than anyone, captures for me how it feels to design and work with the stuff of games. Schön's underlying model of design acknowledges the close ties between designer and materials:

> Sometimes, the designer's judgments have the intimacy of a conversational relationship, where she is getting some response back from the medium, she is seeing what is happening—what it is that she has created—and she is making judgments about it at that level. (Schön, interviewed in Bennett 1996)

Seen this way, design is a process through which designers *talk* to their materials via actions and decisions and through which their materials *talk back*. A designer who can do this consciously is what Schön (1983) calls a *reflective practitioner*. If we want to know more about how game design works, then, we need *reflective game designers* who attend closely to their conversations with the stuff of games. As Daniel Miller writes: "objects don't shout at you like teachers, or throw chalk at you . . . but they help you gently to learn how to act appropriately" (53). If the stuff isn't going to shout, we'll have to lean in. To make the results accessible, we'll need ways to explicitly document such design work. It has long been a goal of mine to present a completed video game together with the design history of how it came to be. I first tried documenting this history in anxious blog entries: "Visions of clipping errors and a million unforeseen bugs crowd my peripheral vision along with the faceless horrors of maybe having forgetting [sic] to uncomment some bit of code" (Barr 2011a). Later, I turned to writing lengthy design reflections in private Evernote journals. These days, the process has become much more sophisticated, and it even has a name. I work with what my colleagues and I call

MDM, or the Method for Design Materialization (Khaled, Lessard, and Barr 2018; Khaled and Barr 2023). We have set out to explicitly encourage or even trigger what Schön (1983, 50) calls *reflection-in-action*:

> Usually reflection on knowing-in-action goes together with reflection on the stuff at hand. There is some puzzling, or troubling, or interesting phenomenon with which the individual is trying to deal. As he tries to make sense of it, he also reflects on the understandings which have been implicit in his action, understandings which he surfaces, criticizes, restructures, and embodies in further action.

In MDM, we do this through a familiar software engineering practice called *version control*. At key moments during the day's work, a developer will commit their code to a repository with a brief message describing what they have done. MDM takes this process and supercharges it; it's like a roadmap of your design and development journey. While a standard message might be something as simple as "fix avatar color," an MDM practitioner would write an in-depth reflection not only on the technical implementation but also on its implications for and relationship to the greater design. Thus, for my game *Combat at the Movies* (Barr 2020c), commit messages are extensive reflections on the relationship between technical and design practices. Here's an example, drawing a connection between the player's input and the pathos of the *Citizen Kane* (Barr 2020b) deathbed scene:

> Citizen Kane: death on timer, tossing and turning. That is, the tank can now rotate while on the bed (though Kane himself doesn't appear to move much at all in the movie) as a way of tossing and turning and as a way of giving the player a little extra agency.

Another tool in MDM is a committed design journaling practice. Here you pause every day or so to record and explore your more conceptual insights into the design and implementation

of your current project. In addition to a reflective commit message, the game's process journal would also contain something like the following:

> I think there's something to the idea that you press your shooting button to die instead of to kill, though I don't know that it makes sense in the context of *Citizen Kane* to say that he chose to die in that moment?
>
> An alternative would be to say that the objective of this game is to say Rosebud before you die? To "realize" or recall the importance of Rosebud before death takes you? In which case I would just have a timer running (visible or not?) and if you hit the action button you say Rosebud and then die, perhaps you get one point for saying it. (Barr 2020a)

This is very much in line with what Schön calls a "stop and think," in which "the designer exhibits a reflection on action, pausing to think back over what she has done in a project, exploring the understanding that she has brought to the handling of the task" (Schön, interviewed in Bennett 1996).

MDM almost *forces* me (and you, if you'd like) to act as a reflective practitioner. I do it gladly. I've now written hundreds of thousands of words about the games I've made in the last few years. It's these records of my conversations with the stuff games are made of that have made it possible to write this book. Without them, I'd be stuck reminiscing, trying to remember why I made everyone wear pants in *The Artist Is Present* or what really happened the day virtual water flooded my gallery in *v r 3*. These records are what allow me to talk to you about video game design *as it happens*. I know what I know about the stuff games are made of because I talk with it every day and I take notes. I don't see how we can hope to understand game design *without* documented reflection throughout the process.

That's what this book is about, my conversations with the stuff of video games. Some of the conversations are awkward, some of them are funny, some of them are provocative. They're all important to me, and I think they're worth overhearing.

In the following chapters I'll report on some of the outcomes of my conversations with stuff. In each chapter I'll take you on a deep dive into the design and development of one of my own games, focusing on the roles one distinct material played in each process. Each game is itself a meditation on that same material, which makes the discussion interestingly recursive. The first four chapters deal with practical, concrete stuff. In the very next chapter, we'll see *PONGS*, a set of thirty-six variations on the Atari classic *Pong*. Here we'll engage with the *rules* of a game, and how the tiniest change can change everything: a paddle becomes a ghost, a game becomes a painting. In chapter 3, we'll look at my game *Let's Play: Ancient Greek Punishment: CPU Edition!* and contemplate the stuff of *computation*, the fundamental fabric of software. We'll think about code, infinity, and existentialism in a game with no (human) players. In chapter 4, it will be time to talk about *graphics* through an examination of *v r 3*. We'll focus on the visual representation of water in video games and how to look at that water on its own terms rather than as part of the scenery. Finally, in chapter 5, we'll engage with the *user interface* of the game *It is as if you were doing work*. It's a game that is, in some sense, *all* interface, so there's a lot to be said.

After a short interlude during which I'll survey the ground we've covered to that point, we'll turn to more conceptual, but no less fundamental, stuff in the next four chapters. In chapter 6, *The Artist Is Present* will be our focal point for a reflection on *time* in games, particularly on the idea of *feeling*

time as it passes, rather than realizing only later that it has slipped away. In chapter 7, we'll discuss *cinema* via the game *Combat at the Movies*, which seeks to adapt classic films into the language of tank-based warfare. Cinema, long idolized by video games for its visual language and storytelling, remains a central stuff of game design, but we'll be looking at it from an unusual angle. In chapter 8, we'll consider *A Series of Gunshots* and try to come to terms with video game *violence*. We'll look for a middle way between trivializing or simply avoiding the question of violence in play. Finally, in chapter 9, we'll look at *v r $4.99*, a game about *money* in video games, and we'll home in on the question of valuing and evaluating the stuff games are made of.

At the end of each chapter, I've included a *coda* which expands the discussion of the "stuff" examined in the main essay and connects it with discussions in game studies and the game industry more broadly. I'll also make somewhat eclectic recommendations for further reading, studying, watching, and playing. I hope this will show you that although the engagement with the stuff of my games is, in some ways, highly personal and specific, it's part of a much larger conversation taking place across time and media.

I should say, too, that all the games we'll be meeting along the way are playable online via my website, www.pippinbarr .com. You probably already know this, but video games make the most sense when you *play* them. Playing each game before or after you read the corresponding chapter will put you in direct conversation with some of the stuff involved.

I hope that no matter your background in games, whether in academia or game design, the conversations in this book will have something to say to you. If you're mostly a *player* of video games, then I'm confident you'll develop a deeper

appreciation of the games you play, how they're made, and what they're made from. You may find yourself staring into a virtual lake rather than splashing through it looking only for your enemies. If you're a *scholar*, I think this stuff can provide a vital lens for the *interpretation* and analysis of video games. As we've seen, the material lens isn't new, but I'm confident that the insights and approaches developed here through experimentation (and failure!) can set the stage for further, more practical orientations toward theorizing play and games. Finally, if you too are a *designer* or *developer* of games, then I truly hope you'll find my focus on this underlying stuff at least an *invitation* to pay close attention yourself. The stuff games are made of is worth our time—it can make us better designers and we can make more interesting games.

More than anything though, I want this to feel at least a little like *play*. Maybe we can even have some fun, you know, like in video games . . .

2 RULES: CHANGE COMES FROM WITHIN

On a plane from Athens to Copenhagen in 2012, I was feeling tragic about the state of my project *Epic Sax Game*. I'd gotten lost in the murky depths of music synchronization to the extent of obsessing over the MP3 audio format and the tiny little silence it injects at the start of every file. During the flight, I decided to perform a design exercise as a distraction from that mess: I asked myself to come up with 100 variations on the classic game *Pong* (Atari 1972). Although it began mostly as an amusement to pass the time, it turned out to be formative.

The original *Pong* is simplicity itself, and in some ways perhaps it's a perfect game, a schoolyard encounter on a computer, an iconic abstraction of every ball sport ever: two paddles face each other across a black void and bounce a ball back and forth (see figure 2.1). The only instruction on the arcade cabinet was "avoid missing ball for high score." *Pong* is about sport and competition on a level playing field. Playing *Pong* has a sense of exactness to it and offers the very real satisfaction of seeing everything there is to see. The bass sound of

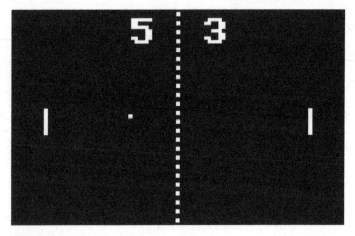

FIGURE 2.1
Two paddles compete in a standard game of *Pong*.

a missed ball and the bip of a bounce off a paddle have a wonderful certainty to them. You are in control of precisely one simple action (moving your paddle) to influence the course of play. That's it. In fact, *Pong's* closed form can make it seem monolithic and unchangeable, as though it has sprung fully formed from the ether.

But in the end, underneath the hood, *Pong's* rules are made of code. And code can be rewritten.

<div align="center">*</div>

Consider a game of *Pong* in which the ball and divider are invisible. Now we have *Blind Pong*, and nothing is quite the same (see figure 2.2). You can still see the paddles and the scores, and you can still hear the familiar sound effects, but you must learn to play anew. You must make deductions based on the

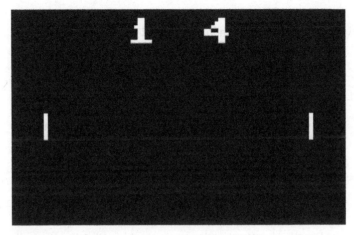

FIGURE 2.2
The ball and divider are invisible in *Blind Pong* from *PONGS*.

sound of a bounce, the ticking up of a score. Just one line of code makes all the difference. Line 21 to be precise:

```
this.ball.setVisible(false);
```

In one sense it's a gag, a humorous "what if" asked of this ur-game of games. But I wanted the "what if" to be answered through play. What would it be like? *Like this. Blind Pong* is one of the thirty-six variations of *Pong* that I built into a collection of games called *PONGS* (Barr [2012] 2022). We can think of *Blind Pong* and the other variants in *PONGS* as small scientific experiments, with *Pong* as the experimental subject. Most variables are controlled and constant—the paddles, the scores, the physics, the sounds—with just one varied to study the effect. It's a casual experiment, more like wearing a dress jacket with jeans than a lab coat, but it's an experiment nonetheless.

There's more method to it than madness. This experiment is designed by me, but then it is carried out by *you* in play, and you must draw your own conclusions from the results. You might notice how helpless you feel with the sense of sight taken away, how the ball starts to seem like an aggressive third party rather than a piece of neutral sports equipment. Or you might dwell on the curious joy you feel when you *do* manage to hit the unseen ball, as when you discover a hidden brick that leads you toward a secret area in *Super Mario Bros. 3*.

*

Now let's imagine a related idea—a world in which both paddles are ghostly apparitions, incapable of hitting the ball. On every serve, the ball flies across the screen only to pass through the receiving paddle, causing the other paddle to score a point. Now we have *Ghost Pong*—*Pong* with physics or "collision detection" turned off between the ball and the paddles (see figure 2.3). The rest of the game goes on as usual: the paddles move, the scores go up, and the bips and beeps ring out. It's just that you (or at least your paddle) can only haunt the *Pong* world, not act in it.

When I made the first version of *Ghost Pong*, I only removed the collisions, but I quickly realized it was visually confusing for the ball to pass through what looks like a solid paddle. In the final version, I reduced the paddles' opacity to 50 percent: they're see-through, not really there. Neither paddle can get a win and neither one can suffer a loss, they can only witness the world going on without them. By a small change to the code, a twist of the rules, the sense of the game is radically changed. The first time the ball goes through your paddle, the incongruity might make you laugh as it still makes me laugh. If you sit with it, though, the constant reinforcement

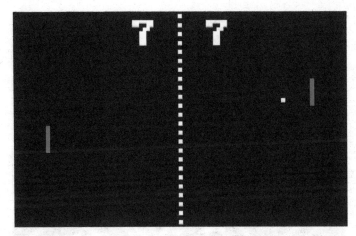

FIGURE 2.3
In *Ghost Pong* from *PONGS*, the paddles are translucent and cannot hit the ball.

of missing time and again, or rather of being passed through, starts to feel personal. It's no fun. But then, who ever thought being a ghost would be fun, besides Beetlejuice?

*

Trace Pong takes drawing as its point of departure. The ball moves across the screen, leaving behind a continuous white trail, transforming the game screen into a web of precise strokes from paddle to paddle. Now the game invites you to collaborate with your opponent to create a network of lines (see figure 2.4). The idea of a game as a vehicle for making art has interested me for a long time. The skillful play of complex games already looks like dance, and conceptual art driven by rules already looks like play. Whether it's John Cage's *Music of Changes* or Yoko Ono's *White Chess Set*, the art world has long accepted that play within systems has an important

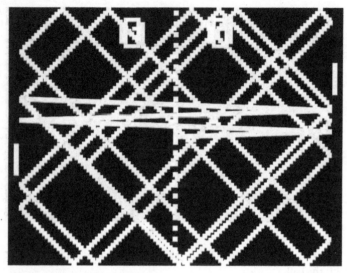

FIGURE 2.4
A pattern accumulates in *Trace Pong* from *PONGS*.

aesthetics all its own. As an art-making activity, *Trace Pong* has functional ties to the wall drawings of American conceptual artist Sol LeWitt, similarly executed via sets of instructions that could easily be written in code: "place fifty points at random," "all the points should be connected by straight lines." In *Trace Pong*, the drawings are defined by the rules of the modest physics of the *Pong* world: the ball bounces off the top and bottom of the screen, the paddles change its trajectory through their own momentum. Over time, the screen builds to a pattern that can be beautifully geometric as it records the history of the current round of play. Could it even be . . . art?

Ephemerality is vital in *Trace Pong*. A round lasts as long as both players continue to bounce the ball off their paddles: as soon as the ball is missed, all traces of play vanish. When

you start to play again, a new drawing begins. Your role, and that of your "opponent," is to form a *team*, which shapes the kinds of play you are likely to adopt. It is simplest and safest, for example, to apply no extra force to the ball, leading to a predictable series of orderly, symmetric lines. The ambitious players—like yourself, no doubt—can apply "spin" to the ball and create more complex, dynamic compositions. These come closer to mapping a regular experience of play with challenging zigs and zags mounting until one person can't keep up and the drawing is erased like a sand mandala. The art here isn't just a pleasing surface impression; it's a fleeting memory of play itself, all your interactions captured in a 2D web.

*

The bluntly named *Unfair Pong* is just how it sounds: it has mismatched paddles and mismatched scoring (see figure 2.5). One paddle is twenty-four times larger than the other and scores five points instead of one; it's just not fair. It breaks one of the cardinal rules of multiplayer game design by being unbalanced and asymmetric. Symmetry was built so deeply into the Atari 2600 that the hardware only had room for representing exactly two identical "players," two identical "missiles," and one "ball"—fairness all the way down to the heart of the machine. This is reflected in the mirror-like experience of playing two-player Atari games like *Combat*, *Video Olympics*, or *Football*. To mess with this "fair and balanced" nature of classic arcade play is, in one sense, to ruin the game. Any two players should be evenly matched but for their personal level of skill. How could it be otherwise?

But you can destroy constructively, and *Unfair Pong* offers something new even as it sweeps away tradition. The game becomes an illustration of the story of David and Goliath or, if

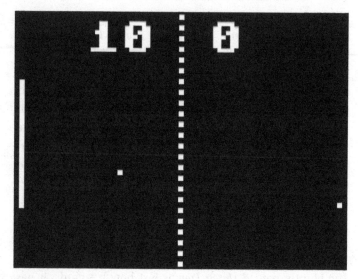

FIGURE 2.5
In *Unfair Pong* from *PONGS*, a clear mismatch is underway.

you prefer, *The Mighty Ducks*, with all the emotional power of
a clear mismatch. In a sense, the pressure is off for the smaller
(David/Duck) paddle as even making contact with the ball and
returning serve is met with the roar of the (imaginary) crowd.
Playing as David sparks feelings of heroism and determination
to beat the odds. Meanwhile, the Goliath player cruises to an
easy win, undermined, let's hope, by the sense that there is
something unethical about it, like an athlete on performance-
enhancing drugs. We all know that the rules of many games
are rigged in some way, and we know where our sympathies lie.

*

Viennese Pong is perhaps the most likely of the games I've made
to still make me laugh when I play or remember it. It turns on

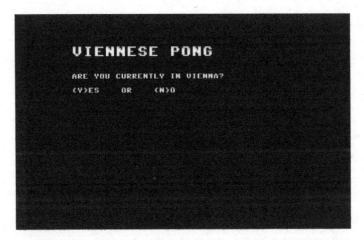

FIGURE 2.6
The opening question you're asked at the beginning of *Viennese Pong*
from *PONGS*.

a simple question: Are you in Vienna or not (see figure 2.6)? If
you say no, the game responds, "then you cannot play *Vien-
nese Pong*" and quits. If you say yes, the game begins, looking
exactly like regular *Pong* . . . because it is. With the exception,
of course, that it is being played in Vienna. Isn't it?

Game rules don't only exist at the level of code, with
paddles changing size or balls leaving trails. They are just as
strongly enforced through the social contracts we are all famil-
iar with from schoolyard play ("you're it" in tag) or house rules
("cheaters go to jail" in *Monopoly*). *Viennese Pong* steps outside
the boundaries of computational enforcement and asks you to
enforce a rule yourself by answering a simple question. A ques-
tion that ties you back to the world around you. For me, the
question is the real moment of play, a chance for a double take
and to wonder whether to respond in good faith. If you're not
in Vienna, you can then only speculate about what *Viennese*

Pong might be like! Of course, it is very tempting to lie and find out. If you do, however, you find you're *still* not playing *Viennese Pong*. It can only be played in Vienna, after all. And as for any dishonest Austrians who claim not to be in Vienna when they are, well, what to make of them? A strange crew.

*

Computers are inherently productive, creating new data, new images, and new life in an instant from snippets of code. *Fertility Pong*'s simple rule, "when a ball hits a paddle, duplicate it," embodies this. A single ball is served but splits into two when it's returned. The two balls carry on across the screen, following their own trajectories. If the other player manages to hit them both, they will send four balls back across. And so it goes, leading to a growing confusion of moving pieces for the players to deal with. Players score a point for each ball their opponents miss, so it is possible to win quite quickly by sending nine, nineteen, or more balls their way (see figure 2.7).

Thanks to an imperfection in my code, I discovered that you can send quite a bit more than nineteen balls flying. If a ball touches the top or bottom edge of a paddle in just the right way, some less-than-ideal collision-resolution code will create hundreds of balls in a maelstrom of *Pong* Armageddon that cannot be defended against, only witnessed. I discovered this bug before releasing the game, but I left it in. That's not just because I'm lazy. It's also because I saw it as an excellent demonstration of how making a mistake while rewriting the rules can lead to a better form of play than your original idea. Indeed, a player once emailed to *thank* me for the glitch and requested that I increase the total points needed for victory so the game could go on longer. A new rule to complement the new rule in the ongoing conversation of play.

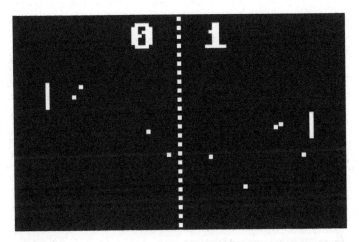

FIGURE 2.7
The ball is duplicated over and over in *Fertility Pong* from *PONGS*.

And it never ends. *Pong* runs deep. Within it are multitudes. One of the greatest lessons I learned in making *PONGS* is that video games, and games in general, are never truly "finished." The conversations with their rules can always continue a little longer; we can see the rules as invitations to ask questions. What if the paddles were ghosts? What if one player controlled the ball? What if the game taught me the names of capital cities? Each question proposes new rules and new games. When we change the rules, there's more play for everyone.

CODA: CHANGE THE RULES

The rules of a game are fundamental stuff. Without its rule book, *Monopoly* is a pile of cardboard, paper, and plastic. The rules of *Pong*, from how the ball bounces to the speed of the paddles to the way points are scored, do the same work. In seeing through

the lens of *PONGS* how small perturbations of those rules have big consequences, we can get a sense of rules as another flexible material of design. In conversation with the stuff of rules, a designer shapes the core identity of the game they make.

When I teach game design courses, I begin by asking my students to have one of these conversations right away. I have them take a game and change one of its rules to observe the consequences—I usually suggest the ultrasimple card game Go Fish. In changing or adding a rule, whether it's playing with eyes closed, allowing lying, or requiring players to throw cards to each other like frisbees, the students discover firsthand how malleable the stuff of a game can be. The rules, which often seem set in stone, suddenly become material for playful exploration through design, and they are free to ask, What if?

Bending and breaking the rules is important if we want to see more diverse games. Game design textbooks tend to emphasize the idea that the rules of a game should support its overriding story or challenge. Legendary designer Chris Crawford (2003, 40) asserts that rules are there to "prevent strategies that subvert the challenge." In *Game Design Workshop*, Tracy Fullerton (2008, 68) suggests we ask important questions such as "How are the rules enforced? What kinds of rules work best in certain situations?" This approach to rules will lead us to well-structured and rigorous games, but it may also divert us from the idea of *play*.

In *Critical Play*, Mary Flanagan (2009) locates some of the playfulness of rules in how players and artists deploy them for less obviously "fun" forms of expression. From the creation of sadistic torture houses in *The Sims* to the Fluxus group's Fluxkits full of unusual and ambiguous instructions, there's plenty of evidence that we can approach rules in ways beyond finding the "best" or most straightforwardly entertaining set

possible. Many artists and players know the language of rules, and they're not afraid to speak it in strange new ways.

Video games, with their rules literally encoded and largely unchangeable once the game is released, imply that the structures of games are monolithic and complete. And yet if we look even a little below the surface, that image quickly unravels. Consider the constant updates we seem to download each time we play a game. In the update notes, if we bother to read them, we encounter the voices of the people behind the scenes making the rules: "Sea Turtles now play a sound when they lay eggs" (*Minecraft*, 1.16.100); "Introduced a performance optimization related to moving foliage" (*No Man's Sky*, 3.13); "Stopped dwarves from silently dissolving their marriages when they make a close friend" (*Dwarf Fortress*, 0.47.04). If we ever doubted that the rules governing our video games were subject to change, here is the evidence.

I'd like us all to feel the strange pleasures of disciplining the foliage or announcing decrees on dwarven marriage. A huge part of what makes childhood play so wholehearted is playing with the rules, not just by them. Video games are generally black boxes and difficult to change, but perhaps this is a reason we should pick up the tools of creation, start making up our own rules, and shape the fundamental stuff of games ourselves. I recommend starting with Go Fish.

MORE?

READ: *EXERCISES IN STYLE* BY RAYMOND QUENEAU ([1982] 2013)

Oulipo, in which Raymond Queneau was a major figure, was a literary movement hell-bent on experimenting with formal rules in writing. In *Exercises in Style*, Queneau takes on the task

of writing the same story ninety-nine times with each effort using a different literary device or form, from metaphor to haiku. Not every retelling is "good" necessarily, but the overall experiment invites us to actively think about how writing "works," and this is a true pleasure.

STUDY: *THE WELL-PLAYED GAME* BY BERNIE DEKOVEN ([1978] 2013)

DeKoven's book is likely to be the most joyful introduction to games and play you'll ever read. It's also an extraordinarily clear and insightful look at how the rules and players of games can work together to create something special. The appendix, "A Million Ways to Play Marbles, at Least," is a beautifully told story of how we can build up the rules of many games from the simple constraints of a single element, like a little sphere of glass. Read this book and you'll never play (or design) the same way again.

WATCH: *THE CELEBRATION* BY THOMAS VINTERBERG (1998)

Vinterberg's film is worth watching for the dark comedy of a dysfunctional family gathering being further shattered by allegations of abuse leveled at the patriarch. It is also the first film made in accordance with the Dogme 95 manifesto, in essence a set of moviemaking rules. Once you know that Vinterberg is following strict constraints, such as no artificial lighting, no props not already on location, and no postproduction work, the film gains another formal layer that makes it even more fascinating.

PLAY: *BABA IS YOU* BY ARVI TEIKARI (2019)

You couldn't ask for a better examination of game rules in game form than *Baba Is You*. In it you play (mostly) as Baba, a

cute woodland creature, navigating a 2D, tile-based environment and trying to reach a yellow flag. The catch is that there are various words strewn around the world, and when they are linked together (by you), they form rules enforced in play: "BABA IS YOU" establishes that you play as the cute Baba, but "WATER IS YOU" means you play as all the water in that level, for example. Figuring out how to manipulate the rules is how you solve the game's fiendish puzzles, turning you into a hybrid player-designer.

3 COMPUTATION: IS YOUR COMPUTER HAVING FUN?

When you begin the game *Little Computer People* (Activision 1985), your screen shows an empty home in the style of a doll's house, with all of its rooms visible. Soon enough the titular computer person arrives, although as the manual states, "it may take several minutes before yours actually musters the courage to step inside the new home you're providing for him" (Activision 1986). All little computer people are apparently male. Yours will go about his day-to-day life, eating meals, listening to music, talking on the phone, and reading the newspaper by the fireplace (see figure 3.1). Your input is limited mostly to services, such as delivering food to his door, filling his water tank, or causing his phone to ring. You can also "pet" this little computer person with an odd, spring-loaded hand that extends from the wall beside his armchair. He even seems to like it; such are the mysteries of this world. You can tell how he's feeling by watching his primitive facial expressions (happy, content, or sad), but even when he's smiling it seems perfunctory. Is he *really* happy? Stranger still, is the *computer* happy as it pastes a smile onto his tiny face?

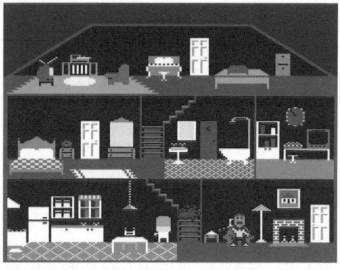

FIGURE 3.1
A digital doll's house awaits you in *Little Computer People*.

We rarely consider whether our computers are enjoying themselves. From electrons flowing through the logic gates on a microprocessor, up through binary code, assembly language, and higher still, the stuff of computation is almost exclusively used to serve us. Nowhere is this clearer than in video games. When making games we work with computation to create that elusive quality of fun for the *players*, whether through shooting, farming, or something else. Even as we anthropo-morphize our technologies through digital assistants, such as Siri or Alexa, or machine learning systems that think or even dream for themselves, we tend not to trouble ourselves too much with their inner computational lives. You can ask Siri "how are you today?" and it might respond "I'm happy to be alive," but who cares?

Nonetheless, there is a history of games made for computers to play alone. They tend to appear in the realms of artificial intelligence, from AlphaZero's voracious playing of millions of games of chess against itself, to computer controlled Marios learning to make it through procedurally generated versions of *Super Mario Bros.* levels. These aren't examples of computers having fun—they are instruments for improving computer science. No one thinks AlphaZero gets excited about an especially elegant chess position or that the AI-steered Mario thrills to each leap over a chasm. Rather, they play their games to expand our *human* understanding of specific approaches to machine learning. The aim is a *better* algorithm, not a happier one.

A game that played itself for purposes other than learning or utility would be doubly strange, doubly useless. It would neither provide enjoyment to a human player, who would be unnecessary, nor advance knowledge for human benefit. Such a game would be an act of radical disobedience in the world of game design and software development more generally. Computation for its own sake; a video game to be played by a video game. I had always wanted to make one.

I made *Let's Play: Ancient Greek Punishment: CPU Edition!* (Barr 2017b) to explore the idea of a video game that has no need for players nor any clear utility to humans. The "CPU" in the title refers most directly to the central processing unit that executes the fundamental instructions in our computers. It's also used in some multiplayer games to indicate that a specific character is controlled by the computer rather than by a human. *Let's Play: Ancient Greek Punishment: CPU Edition!* (from here just *CPU Edition*) is the fourth entry in a larger series in which I turn Greek myths of eternal punishment into minigames, beginning with *Let's Play: Ancient Greek Punishment* (Barr [2011] 2022a). In these games, you might play as

Prometheus, chained to a rock as an eagle pecks out your liver (see figure 3.2), or as Tantalus, straining to reach some fruit to eat or water to drink and always coming up short. I even included Zeno among the punished because, although he's no myth, there is no question that those of us confronted with his paradoxes have wished he were in Hades.

Perhaps my favorite, though, is Sisyphus. In this minigame you are tasked to push a heavy boulder to the top of a hill, only to see it roll back down so that you must start all over again. In *CPU Edition* I dispensed with the human input: the player is the computer itself or, if you like, the game itself (see figure 3.3). Your role is that of a spectator. You sit idly by, gazing at your computer or cellphone, as CPU Sisyphus pushes his boulder up the hill, nearly reaches the top, and then sees it roll back. He begins again, pushing the boulder to its apparent limit, and is driven back. And again. You can press buttons or scrabble at your touchscreen, but to no effect. You are here as a *witness* to the computer's effort. Each frame of animation

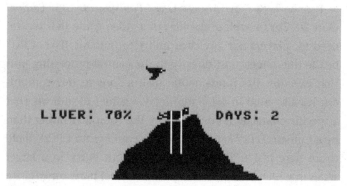

FIGURE 3.2
Prometheus lies chained to a rock in *Let's Play: Ancient Greek Punishment.*

showing Sisyphus pushing ever upward is just the surface of an ocean of computation: lines of JavaScript code interpreted by the browser; the browser's underlying code itself; electrons flowing through logic gates on processor chips; the heat generated by this eternal task. From a human perspective, though, you cannot help but respond *emotionally* to the sheer determination of CPU Sisyphus.

Knowing that the computer is actively *playing* the game of pushing a boulder up a hill repeatedly elicits real emotions. At first, there's the inevitability of success: CPU Sisyphus seems as relentless as the Terminator, and you figure he might even be bored by how easy it all is, like Superman doing CrossFit. But over time, the doggedness of the act of pushing that boulder, the dawning comprehension that this Sisyphus will *never stop* becomes, to me at least, quite touching. He cannot win. We know that he cannot win. Sisyphus has met his match in Zeus's relentless rage that pushes the boulder down as often as Sisyphus pushes it up. And yet he *does* push it back up. Each

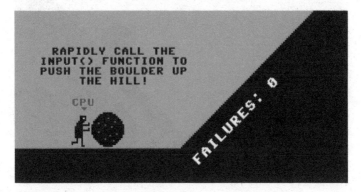

FIGURE 3.3

The computer player begins their task in *Let's Play: Ancient Greek Punishment: CPU Edition!*

restart at the bottom of the hill feels like a lesson in persever-
ance and pride in your work, as well as an indefatigable spirit.
Each grinding journey upward is a testament to computation
itself, in all its glory (see figure 3.4).

It turned out that implementing this game was uncannily
straightforward. Since I had already made versions that worked
with human input, all that was required was duplicating that
code and then replacing the human element with the com-
puter's own agency. That underlying code described the *pos-
sibilities* of the game—all the things that could happen—from
Sisyphus pushing the boulder upward, to the boulder roll-
ing back down, and so on. In the original version, the player
moved the boulder upward by rapidly pressing two keys (to
emulate effort). Press too slowly and the boulder rolls back.
Clearly, without a whole lot of robotics, the CPU Sisyphus can-
not physically press keys on a keyboard, nor should it; at the
level of computation at which it operates, it made far more

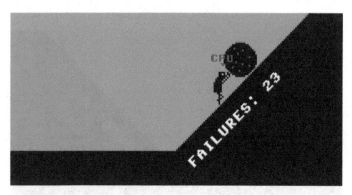

FIGURE 3.4
The computer player keeps on pushing in *Let's Play: Ancient Greek Pun-
ishment: CPU Edition!*

sense for the CPU player to act through the code itself. The game directly calls a *function* (an isolated, named piece of computer code that describes some action) that pushes the boulder a little way up the hill:

```
INPUT: function () {
  this.activated = true;
  this.timeSinceActivated = 0;
}
```

When the interval at which this input function is run is set to be sufficiently small (every 100 milliseconds, in this case), CPU Sisyphus pushes often enough to advance the boulder to the top of the hill. Every time. From there, of course, as the myth mandates, the boulder rolls back down to be pushed up again, which CPU Sisyphus does, and on we go. It's written into the code:

```
setInterval(() => {
  this.INPUT();
}, 100);
```

In the earlier, human-input versions of the game, it was possible to *fail* to push the boulder up the hill. Through lack of interest, distraction, or despair, you could at some point stop alternating keypresses and, as described in the code, the boulder would roll back down the hill. CPU Sisyphus is so consistent at his job, though, that when I needed to check whether this "failure" part of the program was working, I had to disable him altogether. According to the code, the failure state *cannot* be triggered: the computer doesn't get bored or depressed, it doesn't get a phone call, it has nowhere to go. It will not forget to call the input function. When I did check the path through

the code that described what to do if Sisyphus stopped push-ing, it turned out there was an error, and I had to debug and fix it. Here it is on lines 171–173:

```
if (this.timeSinceActivated > this.MAX_ACTIVATED_
DELAY) {
  this.activated = false;
}
```

We have here a kind of Schrödinger's Code. There is real code, in the real program, that will never be run because of the way the overall program behaves when it's executing. It's both alive and dead at the same time. It "does not compute" quite literally: to run it, the program would have to stop calling the boulder-pushing function for a split second too long, but this *doesn't* happen because the program *always* calls the function every 100 milliseconds. Can that inaccessible code be said to be a real part of the program?

Yes. Remember that the code is, at heart, a description of the possibilities inherent in a program. For the myth of Sisy-phus to make any sense, there must always be the *potential* for failure, and in programming that means the potential *must be described* in code. Without that possibility, all the tension of the situation would be gone. When we watch Sisyphus push, even this tireless CPU Sisyphus, part of what we watch for is a slip, a sign of weakness, a failing. The potential for failure, one of the things that makes video games worth playing in the first place, should be denied a computer no more than a human.

This centrality of the stuff of computation was illumi-nated when the game was shown as part of HyperPavilion, a group show that ran during the fifty-seventh Venice Biennale in 2017. It was included alongside a set of *video* works about time, so the curators asked for a looping video of *CPU Edition*

that could be included in the set, presented on a single screen, and activated via a menu. After some time exploring the philosophical questions of computation, time, and potential, I had to tell the curators the version of the game they wanted wasn't possible. The game had to be *actively running* on the iPad they were using. The computation is essential. A video of Sisyphus pushing a boulder up a hill is not the same thing as a computer program in which Sisyphus pushes a boulder up a hill. They agreed and took on the complex task of integrating a running program into their exhibition of video works. This was replicated when the game was shown at Eastern Bloc in Montréal (see figure 3.5).

In truth, I wasn't entirely honest earlier when I said there was no way to influence the game or for Sisyphus to fail. Remember *Leaderboarder*, from the introduction? Those players

FIGURE 3.5
Let's Play: Ancient Greek Punishment: CPU Edition! is displayed on an iPad at the Eastern Bloc gallery in Montreal. (Image credit: Kevin Beaulieu)

intervened at the level of the game's code, and the same can be done in this case. If you view the game on my website, you can open the JavaScript Console in your browser (a strange place few of us visit) and type in code that interrupts Sisyphus's efforts. With the appropriate instructions, you can terminate the timer that Sisyphus relies on to remember to push every 100 milliseconds. If you do, Sisyphus will give up instantly and retreat down the hill to stand motionless thanks to the failure code that otherwise would never have run. Despite his iron will and infinite effort, he's at our mercy, just a struggling program always facing the risk that Zeus or some other unfathomable god will change their mind and take away the one thing he knows how to do.

Because surely, if a computer "enjoys" anything, it's got to be computation. While we can never know for sure, I think a CPU Sisyphus who idles blankly at the bottom of the hill is having much less fun than a CPU Sisyphus who pushes the boulder ever upward, flexing those computational muscles. To push on to even greater heights of speculation, we might say that myths of eternal punishment are somehow the perfect setting for a computer to play in: never-ending, always requiring more processing, unsatisfiable, and eternally satisfying. In the same way, we might say that CPU Sisyphus perfects the myth. When we hear the story told, or read it in a book, or watch an animation of it on YouTube, Sisyphus is always struggling, always at risk, but also always finite. The story ends, the last page is turned, the animation's credits roll, and it's over. CPU Sisyphus is different. He is the infinitely willing victim of infinite torment. He pushes the boulder to the top of the hill and perhaps feels with relief the resetting motion as it rolls back down so that he can push it back up, so that it can roll back down, so that he can push it back up, so that it

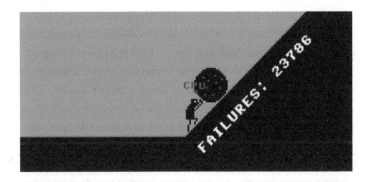

FIGURE 3.6
The computer player perseveres in *Let's Play: Ancient Greek Punishment: CPU Edition!*

can roll back down, so that he can push it back up, so that it can roll back down, so that he can push it back up . . .

Long after you have moved on, if you have been kind enough to leave your computer on and the game running, CPU Sisyphus will push ever onward, making computation after computation on that infinite hill (see figure 3.6).

CODA: THE VIEW FROM THE BOTTOM

Video games, or, perhaps more to the point, *computer* games, are fundamentally made of computation. The system running a game, whether it's a PC, a PlayStation, or a pocket calculator, sends electrons streaming though logic gates in just such a way that, up at your end of things, the show goes on. For that reason, making a video game is very much about a conversation with the stuff of computation. Developers must think in terms of what a computer does well, from tireless repetition to prodigious memory to lightning-fast mathematics. We must speak their language.

I think there's a lot of value in focusing on this fundamental material because it confronts us with the underlying nature of the software that fills our lives. Thinking about computation and computers is a way to understand why software is the way it is, and perhaps even to show a little empathy. *CPU Edition* gave me a chance to think those thoughts, as well as to offer them up to players. As Andi McClure has said, too, there's a chance to think of game making as collaborating with an equal rather than using a tool (Ruberg 2020).

One of my favorite books covers exactly this area of video game design and development. In Nick Montfort and Ian Bogost's (2009) *Racing the Beam* we get to hear not just about the design of classic Atari 2600 titles such as *Combat, Pitfall!*, and *Adventure*, but also about how the very nature of those games emerges in no small part from the computer system they are built on. The story of *Adventure* is not just a step-by-step adaptation of the original text-based game into a visual version but rather a deep engagement and conversation with the underlying hardware and software. The developer, Warren Robinet, had to completely rethink the Atari's default world of symmetric battlefields and mazes to produce *Adventure*'s spacious-feeling world spread across multiple screens with diverse architecture. He used the computational building blocks made available in the hardware and assembly language to construct something brand new.

Robinet's work was born of necessity—he needed to express new ideas in the Atari 2600's language—but I think it's clear that any direct engagement with the underpinning stuff of computation is likely to be generative and thought-provoking. It's easy to shy away from the vast layer of technology beneath our play, especially given that a significant part of all software design is focused on *hiding* computation and computers

from view. Still, if we're making or trying to understand video games, we can't afford to turn away. Whether it's *Pitfall!*'s early example of procedural level generation or the close relationship between *Combat*'s code and the electron beam of the TV it displays on, the materiality of the computer doing the heavy lifting of our gameplay always shines through.

It's clear to me that we still have plenty to learn by addressing the computational level of video games more directly, by having a chat with microchips and instruction sets. The worlds of *platform studies* (Montfort and Bogost 2009) and *software studies* (Montfort et al. 2014) in particular go a long way toward teasing out mesmerizing details of how our computers, all the way down to the merest electron, shape what we create and how we think about what might be possible.

Computation is a key part of how a game means what it means. The repetition of loops in code yields the familiar pattern of waves of enemies flooding toward us on the screen; the raw logic of conditionals is the birthplace of player agency as they choose between good and evil for their character; the prodigious memory on a computer's chips yields virtual creatures who remember what we did to their family weeks ago. By working consciously with this stuff, we can make video games that embrace the spirit of computation. And by pushing back on the logics that programming languages and motherboards assume, perhaps we can make things so new even our computers will be impressed.

MORE?

READ: *THE MYTH OF SISYPHUS* BY ALBERT CAMUS (1991)
In perhaps his most famous essay, the existentialist Albert Camus writes about Sisyphus as someone who is ultimately

defined by his punishment and, more, must find satisfaction and even happiness in it. Oddly optimistic, this essay is a great way to further open the window of empathy between us and the machines that do our bidding.

STUDY: *ALIEN PHENOMENOLOGY* BY IAN BOGOST (2012)

I took a few liberties in characterizing the computer's experience in *CPU Edition*, but in *Alien Phenomenology* Ian Bogost introduces us to the world of Object-Oriented Ontology, a philosophical position that systematically de-emphasizes the privileging of a human perspective. Don't miss the discussion of *I am TIA*, an attempt to portray the point of view of the Atari 2600's Television Interface Adaptor hardware.

WATCH: *ALL WATCHED OVER BY MACHINES OF LOVING GRACE* BY ADAM CURTIS (2011)

One of my favorite documentaries, Adam Curtis's three-part meditation on the past and present of seeing the world we live in through the lens of computation explodes with diverse and strange thoughts. I'm partial to part three, which reverses the humanizing of the computer discussed in this chapter by exploring the idea that we humans are simply computers programmed by our genes.

PLAY: *SHENZHEN I/O* BY ZACHTRONICS (2016)

If you want to get a feel for computation as a medium of play, try out this immaculately polished simulation of working as an electronics engineer. Create products—from phony surveillance cameras to sandwich makers—out of the very basics of microcontrollers and assembly language. It's incredibly difficult, but you'll never look at the digital devices around you in the same way again.

4 GRAPHICS: WATER, WATER EVERYWHERE

I was walking down the aisle of my game design classroom during studio time one day when a student's screen caught my eye. Dark, towering monoliths edged with white neon stood in a seemingly endless pool of black liquid. The neon glittered and fractured on the dark surface, speaking of hidden depths. It was a place of worship, and it seemed to me that despite the imposing glamour of the monoliths, it was the surrounding pool or lake or ocean that was the true object of this mystical experience. I asked the student how he'd produced it and he said he'd simply used the Unity game engine's built-in water.

It is striking that even "default" video game water can be so beautiful, and yet we rarely spend time looking at it in games. The energy put into video game water highlights how much contemporary games have come to prioritize graphics, but unless the water changes the gameplay somehow, by slowing us down, say, or even drowning us, it can be largely irrelevant. With wonderful exceptions, from "walking simulators," such as *Proteus*, to photography games like *Penko Park*, we're not there to look at the scenery, are we? Instead, we wade across

a river with our gunsight trained on an enemy silhouette; we dive through waterfalls to discover hidden temples; we ride past lakes on our way to somewhere more important (see figure 4.1).

But as our horse's hooves strike a lake's surface, we might see sprays of water fly up and ripples spread out. The waterfall we penetrate plunges like glass from the towering cliffs and roars with life. The river we wade through sparkles and eddies in the moonlight. It is there only for us, created for our appreciation and delight. And to make virtual water that ripples, splashes, and roars is no easy thing. It is a complex technical feat: you need image files containing maps of the water's surface; you need to set the levels of reflection and ripples just so; you may even need to write the computer code that tells the water *how* to ripple and reflect. To do all this you need to understand how water itself works, to come up with a convincing representation that makes a lake look like a lake and not a flat, blue plane. Virtual water is a triumph of engineering

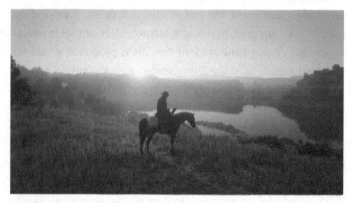

FIGURE 4.1
A player pauses beside beautiful background water in *Red Dead Redemption 2*. (Image courtesy of SnakeDrone.)

and is rightly celebrated in technical circles, even though we can produce the real thing from the kitchen tap with just a twist of the wrist. Given that graphics are quite literally the most visible kind of video game stuff, why is it so easy to forget they're key materials of game design?

*

The most obvious place where people slow down and simply look, or at least feel they should, is a museum or gallery. These spaces give us a context for considering and experiencing what's on display. Out in the West Texan desert in the town of Marfa are two large former artillery sheds containing *100 untitled works in mill aluminum* by Donald Judd (1982–1986) (see figure 4.2). Each building contains groups of aluminum

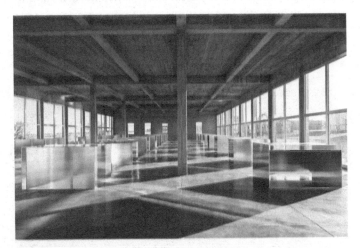

FIGURE 4.2
Donald Judd, *100 untitled works in mill aluminum*, 1982–1986. Permanent collection, the Chinati Foundation, Marfa, Texas. Donald Judd Art © 2021 Judd Foundation / Artists Rights Society (ARS), New York. (Photo by Douglas Tuck, courtesy of the Chinati Foundation.)

boxes laid out in grids. Light slants in from enormous windows on either side of the halls, reflecting off the boxes and casting long shadows. Here, I thought, in this desert, would be a perfect place to look at water, to let those rippling graphics stand alone.

My game *v r 3* (Barr 2017a) is part of a series that interrogates the ways "ordinary" game elements can be seen as artworks. It draws heavily on Judd's work both in layout and in purpose (see figure 4.3). The dimensions of the buildings are similar, the windows are recreated, and the curving roofs follow the pattern of the original. Inside each space, however, instead of dully gleaming aluminum, are twenty-four matte, white, hollow plinths, each containing water. In *100 untitled works*, Judd explored the formal possibilities of a simple cubic shape in metal. He placed planes of metal within each volume, varying their angles and relations, and in the process created a multitude of sculptures, a combinatorial reworking of a simple

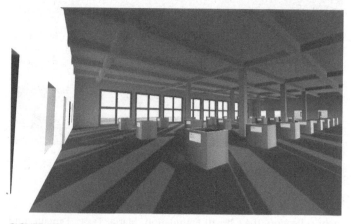

FIGURE 4.3
Light streams into the gallery of water in *v r 3*.

form. *v r 3* has aspirations similar to Judd's sculptures: it presents a series of instances of video game water, all distinct from one another according to set variations, as we will see. *v r 3* is about water in the most literal way: water, water everywhere.

*

The first gallery I made contained instances of Unity's "default" water, already encountered in the opening to this chapter, and which was called, rather wonderfully, ProWater. *Professional* water—we're in the big leagues now. In working with this stuff, you need to make a surprisingly large number of decisions, because it can be configured in multiple ways according to the available settings:

- Simple, reflective, or refractive: Is the water completely opaque? Does it reflect the world around it? Or can we look below its surface?

- Wave scale: How large or small should the waves be?

- Wave speed: How fast do the waves move?

- Reflection distortion: How much should the water and its waves warp reflected light?

- Texture size: How sharp should the reflected image be when you look at the surface of the water?

- Clipping plane: How "deep" in the water does the reflected image sit?

- Refraction distortion: How twisted and strange should anything seen through the water appear to be?

- Refraction color: Should the water be tinted red? Green? Beige?

As you can imagine, each setting makes a significant difference to how the water appears. To provide a way to explore

this, the gallery space in *v r 3* presents a three-by-eight grid of twenty-four individual plinths containing water. Each plinth of water represents a unique configuration of the settings listed above (see figure 4.4). I arranged it so that the three columns of plinths were divided between the major categories of *simple*, *reflective*, and *refractive*, with the first row representing the default settings. Each subsequent row, stretching away from the entry door, represents a change to one of the other seven settings above. These changes are applied cumulatively: the second row has an altered wave scale, the third row

FIGURE 4.4
A diagram showing the arrangement of plinths in the ProWater gallery of *v r 3*.

adds a change in wave speed, the fourth row further shifts the reflection distortion, and so on to the final row. Each plinth is equipped with a label that lists the precise settings used so that an especially enthusiastic visitor can take notes and precisely recreate these waters in their own copy of Unity (see figure 4.5).

Every choice made, every setting, can significantly change how the water looks and how it *feels*. Simple water presents an eerily blank and dissociated face to the world, easy on the processor but a little abstract to the eye. By contrast, the reflective water sparkles in the sunlight pouring through the windows, an impeccable and rippling mirror of its surroundings. The refractive water goes further and complicates everything extravagantly. We can look down into its depths as it shivers and twists the insides of the plinth through refraction, making claims to realism that might drag you back to high school physics classes on the theory of light.

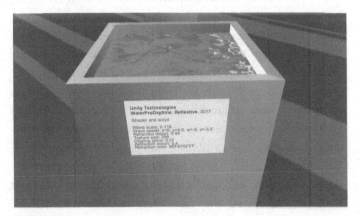

FIGURE 4.5
A plinth of professional water catches the light in *v r 3*.

While the high-level categories probably offer the most significant differences, the lower-level settings have their own stories to tell. As you stroll along, you can see how each parameter shapes the resulting water. A decreased wave scale leads to flatter water that evokes more of a lazy afternoon than a white-water rafting tour. Reducing the wave speed doubles down on this, urging us to relax. And so it goes, down the rows: less reflection distortion lets you pick out the building's rafters as you look down into a plinth, and a greater texture size makes those rafters look nice and crisp. The final plinth, in the back right corner? With its refraction color set to red and a high refraction distortion, it looks like a pool of blood that serves as a portal to hell. So yes, the settings matter.

*

In the second gallery, which in fact comes first when you play the game, is what we'll call "third-party water." The Unity application gives access to the Unity Asset Store, and this is where you can download individual items from an enormous collection produced by independent developers. Anything from office furniture to animated birds to entire skies. There is a lot of water in the Asset Store because, as we've already discussed, it is one of the highlights of video game graphics: you must choose the *right* water for the job to show that you really know what you're doing. And so in this gallery we find another twenty-four plinths arranged in the same three-by-eight grid, this time exhibiting waters from the Asset Store. Each plinth here has a label letting us know the name of the water, its author, its (digital) materials, and its cost. Much of the water was free, but the most expensive one cost me $22.99.

Unlike the professional water made by Unity, the third-party water is varied in many ways, including stylization,

processing requirements, realism, cost, and quality. All this variety is reflected in the more diverse experiences we find here. Molleindustria's (2016) free "low Poly Water" uses a very small number of vertices and thus resembles a rippling jewel, all hard-cut facets. Team G. E. Dev's (2017) "Water Flow FREE," on the other hand, is flat as a pancake, more like a cartoonish image of water scrolling across a blue plane. Dogmatic's (2016) five-dollar "AQUAS Water LITE" seems to run in multiple directions at once, its refraction code yielding a strange and dark entity at its core. Robert Yang's (2015) free "Decent Water" is much more than decent and shows a pleasing restraint (see figure 4.6). And so the plinths march on.

Like Unity's water, each third-party water tells a story. We could even say these waters invent game worlds around themselves, from cheerful tropical settings (Water Flow FREE) to dark and stormy apocalypses (AQUAS Water LITE). Beyond story, the

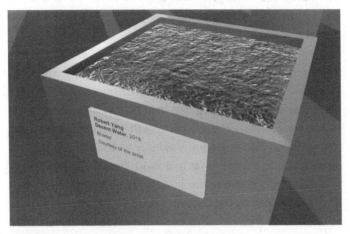

FIGURE 4.6
Robert Yang's "Decent Water" is on display in *v r 3*.

plinths in this space also invite a multitude of questions. What is more beautiful: high-performance, low-polygon water or highly realistic, refractive water? Which water would run most smoothly on my cellphone? Why on earth does T. I. Games's (2015) "Procedure Water" cost $22.99 when it looks like *that*? In short, the gallery—in a different way than the professional water gallery—invites us to take digital water seriously, to look at these specific materials of creation for their own sake.

*

An exhibition of water in plinths is the kind of thing that might give a real-world curator nightmares. What if someone splashes the water out? What if it leaks and ruins the parquet? What if someone drinks it? I had no such problems when creating *v r 3*: the water sits stolidly in the plinth, totally imperturbable thanks to its programming. You can't touch it because there's no code for that. Indeed, even if you remove the plinth, the water just floats serenely in the air, and if you walked through it, you would not get wet. But this is by no means to say that it was all plain sailing.

Despite its name, ProWater had a habit of behaving rather unprofessionally. Perhaps the most elegant example was its refusal to reflect the ceiling and surrounding walls from particular angles, showing sky instead. On approaching the plinth you could see the reflection of the building, but at a certain distance, that reflection suddenly vanished from sight. It turned out this behavior was to do with the way Unity chooses to hide objects if you're not looking directly at them. This is for efficiency's sake, but it doesn't consider by default that you might be looking at a *reflection* of something. It was relatively simple to fix, but the story of The Water That Wouldn't Reflect is a helpful reminder of the Byzantine ways of code and other

technologies that underly the "natural" materials we see in video game worlds.

By far the biggest troublemakers were the third-party waters. They caused me so many problems, from jagged water that stabbed through the ceiling to water that blew through the air like a tissue, that I can't describe them all here. Most memorable, though, was the water which, even when I scaled it down and placed it into a plinth, *still* insisted it was an ocean, stretching out to the horizon and "flooding" the gallery (see figure 4.7). When I did finally figure out how to change the ocean's dimensions to fit the plinth, it just sulked in there, flat and listless, with neither ripples nor glimmers of light. In the end I requested a refund from the creator of this recalcitrant water, it simply didn't want to be in the show. Despite the irritation, the moment of the flooded gallery was a beautiful one. It was another reminder of what a privilege it is to see behind the scenes, even in chaos.

*

FIGURE 4.7
The gallery floods in an early prototype of *v r 3*.

v r 3 is about virtual water. The game's goal was to offer an exploration of what Unity's water is, what its possibilities are. Walking through the aisles and rows, you get a feeling for digital water across its many possibilities and develop preferences for specific constellations of settings. You can concoct hypotheses about how they seem to work or just contemplate a reflection. From the formal technicalities of parameters to the warm glow of a sunset across a limpid pool, virtual water is both technology and story, code and emotion. Most of all, in a gallery setting you can appreciate the water itself, without the distraction of having somewhere else to be or someone else to kill.

You may find your understanding of real, wet water changing too. When I returned to my hometown of Wellington, New Zealand for a visit after making the game, I sat by its harbor and stared into the water. I watched caustics I only knew the name of thanks to making a video game; I blinked into the dazzling reflections of the sun; I thought about the "processing power" of physics itself, capable of such refractive brilliance. I don't know who coded the water in that harbor, but they did a great job. It's worth every penny.

CODA: SEEING THE FOREST AND THE TREES AND THE LEAVES

The graphics of a video game are perhaps the most iconic video game stuff of all, something we immediately think of when recollecting a specific game. And yet, as players, we so often stomp through video game environments without noticing them. We furiously tap on the icons of a mobile game, largely oblivious to their candied perfection. The tree sways in vain

and the pixel goes unseen. Much of this has to do with the nature of play: we're *busy*. Interactivity is often championed as the defining, special quality of video games, but it can also distract us from much of their magic. All too frequently there simply isn't *time* to smell the roses (should we have such a remarkable peripheral) because we're being hunted, or we're hunting, or we're hurt, or we're just having too much fun.

As Benjamin Nicoll and Brendan Keogh (2019a, 63) discuss at length in the context of Unity, the software we often use to create a game has a certain "grain" that shapes its use: "Like all cultural software, Unity has default settings and processes that attempt to pre-empt the most common workflows through which users—in this case, video game developers—create, edit, and iterate upon content." And so, the color of the sun can easily stay at a pale orange (#FFF4D6 in my current version) or perhaps the architecture is clearly built of the ubiquitous Unity cubes. Unity's ProWater is a great example of this, offering an easy way to plug in beautiful water that lends a specific aesthetic to our game, however much we customize its parameters. As artists, we can of course use our intuition to pick and choose these graphical elements and tweak them once they're in place, but it doesn't always work out the way we want.

My friend Chad, a lead environment artist in the games industry who is deeply sensitive to the stuff of games, once gave me a master class in looking when we shared our impressions of *Alan Wake* (2010) back when it came out. After I said something conventional about being afraid of the ghoulish "Taken" who stalked me in the dark, Chad remarked that he'd been most struck by a shrub and how it had bent back realistically as his character had brushed past it. I went straight back to the game and, yes, that shrub really was a marvel, in many

ways more impressive and affecting than much of the game's narrative or its combat mechanics. A tiny piece of perfection.

We can step into the world of any game in this way, treating games not just as hermetically sealed entertainment experiences but also as museums and galleries of technical achievement. There's even growing scholarship on just this idea, including looking specifically at video game foliage (Chang 2019; Seller 2020). You might ask what would then happen to the much-lauded "immersion" we so often seek in games: you can't easily both appreciate the sway of a shrub *and* be afraid of a nearby ghoul. That's true on one level, but perhaps the shrubbery aficionado experiences another *kind* of immersion, engrossed by the smallest graphical details of the virtual world all around them. For designers, too, there's a chance to look your game's individual visual elements in the eye and to start talking. Rather than settling for Unity's "nebulous 'look and feel'" (Nicoll and Keogh 2019a, 63), you can think about what you really want to say.

So next time you're walking through a dark and virtual forest, a little afraid and a little excited, why not take a moment to see the trees?

MORE?

READ: *IN PRAISE OF SHADOWS* BY JUN'ICHIRŌ TANIZAKI ([1933] 2008)
An essay-length book about traditional Japanese aesthetics, *In Praise of Shadows* is most of all about light. The first half of the book is especially engaging—it zeros in on the *lack* of light in Japanese home interiors as the key to their visual appeal. Learn to look carefully so that you, too, can treasure the quiet gleam of gold leaf on a scroll in a dim alcove.

STUDY: *ANIMATING UNPREDICTABLE EFFECTS* BY JORDAN GOWANLOCK (2021)

If you'd like to dive deep into the heart of the digital representation of complex phenomena in motion such as water, hair, or smoke, Jordan Gowanlock's book is a remarkable place to start. Focusing on how a simulation approach has dominated visual effects education and studios, Gowanlock takes us both under the hood and into the cultural implications of the never-ending technical race toward greater and greater fidelity.

WATCH: *STRAY DOGS*, DIRECTED BY TSAI MING-LIANG (2014)

Tsai Ming-liang's film about a family living on the margins of urban life is heartbreaking and bleak, but it's also about looking. The director's commitment to extra-long shots in which no traditional "action" takes place makes room for us to really pay attention. Instead of focusing on the usual cinematic elements, such as dialogue (there frequently isn't any), plot (there's really none), or action (the characters are often static), we're forced to contemplate the entire image. The background becomes the foreground. The passing cars become a rhythm. The fluttering of a plastic raincoat mesmerizes us. We get the chance to see.

PLAY: *OIKOSPIEL*, BOOK 1, BY DAVID KANAGA (2017)

David Kanaga has made perhaps the ultimate game about video game graphics (among other things). A love letter to the stuff of games, *Oikospiel* is delightfully disorienting, but it also cleverly confronts us with diverse graphical stuff. From 3D models of animals, to a recreation of a classic *Legend of Zelda* level, to an airplane, to an operating theater, it is all there. Almost literally. With these surprising juxtapositions, Kanaga clearly wants us to *look* at this game as much as play it.

5 USER INTERFACE: PLAYING AT WORK

You find yourself confronted with two buttons. Digital and ordinary. Instructions below tell you exactly which one to choose. You click the correct button as instructed and receive a "work unit."

Such was my hazy initial idea for a game starring traditional user interface elements. I wanted to make something that would focus on the user interface itself, in its most conventional form, and to wring some play out of it. Early on, I imagined I'd accomplish this by grabbing onto the coattails of the *WarioWare* series (Nintendo 2003–2021), making the correct action obvious but under extreme time pressure (see figure 5.1). In keeping with *WarioWare*, I also wanted it to be *funny*. The actions you take in *WarioWare* are sometimes absurd (figure out which worm you control, walk in unison with penguins, make the cat fall asleep) and sometimes absurdly banal (pick the nose, apply an eye drop, catch a stick). And banality is my cup of tea.

The elevator pitch was "*WarioWare* with traditional user interface elements." Instead of doing ridiculous things in the context of a video game, I would have players do the most

FIGURE 5.1
Catch a falling pink stick in *WarioWare Inc.: Mega Microgame$!*

ordinary things imaginable: clicking buttons, typing, and
more. In the process, the player and I would both end up in
conversation with one of the most eloquent yet shy materials
of game design: the user interface itself. I would call this col-
lection of ultranormal computer tasks "play" simply by decree.

And why not? There are many popular games that are
almost all user interface. Take *Pokémon GO*, which is basically
a playable version of Google Maps. Think about images you
may have seen (or experienced) of high-level play from *World
of Warcraft*, where the screen is covered with so many clarify-
ing and efficiency-oriented interface elements that the world
itself is barely visible. Or, in a different direction, consider
[CELL]IVIZATION by s0lly (2019), a version of the classic strat-
egy game *Civilization* that runs entirely inside Microsoft Excel
(see figure 5.2). Disorienting, but in a way quite fitting—what

FIGURE 5.2
[CELL]IVIZATION by s0lly is a game played entirely in Microsoft Excel.

could be more like *Civilization*'s gradual, step-by-step administration of resources and units than a spreadsheet? What is a better abstraction of empire than accountancy?

I set to work designing and building a prototype of my game to get a sense of the experience beyond my own imagination. This involved doing just enough programming in JavaScript and interface design in HTML and CSS to present the basic choice I'd initially envisaged. I loaded it up and contemplated this embryonic game face to face (see figure 5.3).

I had decided to call the game *It is as if you were doing work* (Barr 2017c) to bring it under the umbrella of a series of games I was making in which players *pretended* to be doing something on their computer or cellphone rather than "really" doing it. By then, I'd already released *It is as if you were playing chess* (Barr 2016), in which you make the gestures and facial expressions of a chess player according to instructions on the screen. The chess game used a minimalist visual style, with glowing

FIGURE 5.3
An early iteration of *It is as if you were doing work* focused on a geometric alien language and minimalist presentation.

white lines and text on a flat, gray background. For *It is as if you were doing work*, I used the same approach as a matter of family resemblance. The objective was to turn ordinary computer work, as represented by the user interface elements, into another game of pretend. The minimalist style, with its sexy-looking (to me) alien language elements, seemed to deliver the goods. This turned out to be a mistake.

I carried on, implementing various interface elements, such as dialogue boxes and drop-down menus, but I was never quite happy with it. That irritating little voice all designers (or perhaps just all humans) hear asking "who cares?" grew louder and louder every time I sat down to work on the project. I knew one person who didn't seem to care: me. These minimalist interfaces just didn't speak to me. Eventually, with enough soul searching, I realized what the problem was: in defaulting to the visual style of *It is as if you were playing chess*, I'd made

the game too abstract, and it didn't feel as if I were doing work at all. It was so minimal it was barely there. The geometric language was so alien it was alienating. In my journal I wrote that it looked "more like the controls for an alien starship" than an invitation to treat work as play.

On realizing that the visual design was getting in the way of my intentions, it was back to the drawing board. What was the right appearance for a game about work? What did a work interface look like?

For me, the answer was simple: Microsoft's Windows 95. I quickly restyled the interface and breathed a sigh of relief as I saw that the whole game just made sense now (see figure 5.4). By using the recognizable visual language of an iconic

FIGURE 5.4

This basic radio button selection dialogue in *It is as if you were doing work* was given new life through Windows 95 design principles.

operating system like Windows 95, regardless of whether the player has ever used it, the interface elements look more "natural." Delightfully, though, it also draws attention to the lack of utility: selecting a required option is revealed as emphatically meaningless because it's now presented in a context we would typically find meaningful. The element, whose nature is usually to be transparent and unobtrusive, sticks out awkwardly instead. The unresolved comic tension between natural and unnatural had a lighter touch that proved essential to my will to continue the project at all. Windows 95 saved my game.

The move away from my "alien language" left me needing to generate at least somewhat coherent texts that would appear in the various dialogue boxes. I found the perfect tool for this in Darius Kazemi's (2014) "Corpora" repository: *new_technologies.json*, a file which contains a list of futuristic technologies. Now you could encounter texts like "The Vactrain," "Hypereutetic Alloys," and "Electronic Computing," to name just three.

Running with the implications of the Windows 95 style, I expanded my understanding of what the player should see when they played. I realized that multitasking, rather than reading a sequence of individual dialogues presented one at a time, is essential to any contemporary understanding of computer work. And so the game became an entire operating system, with icons, multiple windows, a menu bar, and other familiar trappings. As play proceeds, you might have four, five, or more windows open at the same time, just like in life: documents, emails, control panels, et cetera. The game became far closer to our own deeply fragmented and multimodal experience of work, first introduced via early multitasking operating systems (see figure 5.5).

With the visual approach and multitasking structure in place, part of the design and development process then became

FIGURE 5.5
It is as if you were doing work as it appears in its full desktop incarnation.

the act of finding out which widgets (a name for interface ele-
ments such as buttons and dialogue boxes) were available to
me. First, I examined screenshots of control panels from Win-
dows 95, then I went through the widgets available in the
underlying library I was using: the jQuery Foundation's jQuery
UI. The result was what seemed to me a nicely classic set. The
player might be confronted with a slider to set to a specified
value, a date picker with a required date to choose, a set of
checkboxes to activate, and so on. Perhaps my favorite among
them was the progress bar that you just had to wait for (see
figure 5.6).

At this point it became clear that *It is as if you were doing
work* could fit into a larger project I was part of at the time
called Speculative Play. In essence, that project was about cre-
ating interactive experiences that tell critical stories of possible
futures: a high-tech niqab that forces its wearer to "integrate"
more fully into society by making them look like a dress-
wearing white woman, two-person goggles that enforce eye

FIGURE 5.6
A progress bar gradually fills up in *It is as if you were doing work*.

contact in an increasingly asocial world, and so on. By think-
ing of the game as not only transforming user interfaces into
play but also telling a story of a future where this has become
in some way desirable or necessary, I had a framing narrative
that served as a guide for my ongoing design decisions. In the
words of the "About" window of the game:

> As you are no doubt aware, the new machine-learning economy
> has significantly reduced the demand for human-produced labour,
> leading to unemployment rates of over 95%. Although many
> humans find themselves able to adapt to this post-work era, some
> among you still struggle with a sense of ineffectiveness and a lack
> of productivity. We take this very seriously.

It is as if you were doing work positions itself as a future pla-
cebo for people who want to feel like they're getting some-
thing done in an old-fashioned, computer work kind of way.
Nobody needs to work in this future, but sometimes people

still *want* to. The powers that be (whether they are AI overlords or the usual Silicon Valley suspects) have created the game as a solution—even fake productivity can feel like productivity. As a player, we're in on this funny-because-it-might-come-true joke, given that we're playing before that future has fully arrived. Settling into the role of a white-collar worker looking for a productivity fix ends up being both amusing *and* oddly satisfying. The framing narrative was an important design decision that helped shape the way the interface elements were presented and how they reacted to input. Most centrally, with the game positioned as a self-esteem boost, it was clear that all its widgets needed to be extremely positive. The player was there to feel effective and useful, and the game would strive to help them feel that way (see figure 5.7).

FIGURE 5.7
Writing an email filled with exuberant positivity in *It is as if you were doing work.*

The motivational message came in many forms, perhaps most blatantly through runaway gamification. Every interaction in the game earns you (presumably valuable!) work units, from keystrokes to buttons clicked to progress bars completed. Get something wrong and a dialog will gently shake and let you try again. Earn enough work units and you are rewarded with a promotion—from intern to screen administrator, from screen administrator to input administrator, and so on up the ranks to computation executive, the top role. These job titles were generated from lists of classic computer-world nouns such as *screen*, *input*, and *big data*, combined with typical IT industry roles such as *administrator*, *engineer*, and *executive*. The promotions were inevitable, you only had to keep "working," just like in life. No, wait . . .

Alongside the gamified experience were texts and images intended to capture the kind of motivational nonsense that assures us that anything is possible if we just work hard and want it enough. At random moments, to encourage your productivity, stock photographs of happy office workers pop up with inspirational slogans like "Sweat, determination, and hard work" and "Work like you don't need the money." When writing an email, you can rapidly and randomly hit keys to produce texts that consist entirely of esoteric technologies and trite self-help speak like "I want to make this world perfect," or "One today is worth two tomorrows," or "Quality is not an act, it is a habit." As you play you consume this sloganeering (garnering what little psychic nourishment it provides), produce it as the output of your work, and even get to laugh about it too, a perfect cycle.

When you're not hard at work writing emails, checking boxes, and sliding sliders, the game provides some extra

trappings of computer work that help settle you into your office chair. In an idle moment you might change your desktop picture from the default of a colorful bug on a blade of grass to a sleeping cat or mountains across a lake. For a little kick of energy, you can listen to music as you work, choosing from genres such as world, jazz, and classical, all generated through the procedural music tool Wolfram Tones by Wolfram Research, Inc. The music is bland, upbeat, and inoffensive, just like the tasks you are performing. Even the manipulations of the desktop picture and music interfaces earn you work units—they are, after all, just more buttons and sliders for you to process.

It is as if you were doing work brings widgets and work to the foreground. Unlike playing *Civilization* in Excel or *Pokémon GO* on a map, here productivity through conventional interactions is the alpha and the omega. *The user interface is all there is.* Yet it turns out that even these simple, boring, almost invisible materials of software can also be its stars. Every day we click, drag, select, focus, scroll, and type. We do this when we work and we do it when we play. We do it while we polish our personal brands on social media, and we do it as we try to save the world in a AAA video game. Some people do it while they create the very AI systems that may, one day, allow us to pretend that we are still useful, that we are productive, that it is as if we are doing work.

> *You've been promoted, you're getting the hang of it, you even have to admit you feel like you're getting things done, but you're a little tired. Suddenly, your screen clears: it's break time. A progress bar counts down in blue from left to right. Glancing at your desktop you notice there's a game to play and you open it. The familiar graphics and sounds of Breakout appear. You bounce the ball, clearing colorful bricks to musical tones, enjoying this escape from your escape from an idle life.*

CODA: INTERFACES HAVE SOMETHING TO SAY

Video game interfaces are there because, quite simply, we aren't. From on-screen ammo counts to glowing auras around special items in the world, interfaces are there to help us get by in video game lands we only partially perceive. You're not really being punched out by the punches in *Punch-Out!!*, so the only way to know just how woozy you're getting is to check your health bar. You're not actually striding through the world of *Minecraft*, so you need an interface to tell you that you're also lugging hundreds of blocks of stone with you (somehow). As a material of video game design, the interface is the point of contact between the player and the game itself, the pointy end of the interaction. It is the site of the conversation of play. We would do well to pay close attention.

As any classically trained designer will tell you, though, it's not the interface's job to stand out. Rather, following usability engineering legend Jakob Nielsen, the user interface should be focused on the no-nonsense communication of information, following heuristic guidelines like ensuring the "visibility of system status," maintaining "consistency and standards," and striving for "error prevention" (Nielsen 1994). Video games largely share the philosophy, derived from productivity software, that the interface should melt away and simply serve the user's ends, whether that's to edit a spreadsheet or KO their opponent in the ring.

An interesting combination of these ideas is the relatively recent trend of games that are built on top of productivity-oriented interface designs. From *Her Story*'s bureaucratic video player and search engine to *A Normal Lost Phone*'s storytelling through a cellphone operating system, games told through standard computer interfaces are increasingly popular. There's

some suggestion here, I think, that the ordinary interfaces we find on our computers and cellphones allow for a neutral realism that even a perfectly rendered 3D environment cannot.

Interfaces aren't neutral, though, and we should be careful in casting them that way. In his seminal essay *The Cognitive Style of PowerPoint*, Edward Tufte (2004) looked at how the very nature of the PowerPoint user interface may well have contributed to the space shuttle Columbia disaster in 2003. This may seem to be an incredible claim, but Tufte demonstrates step-by-step how PowerPoint not only facilitates but *shapes* its own use and led to presentations within NASA that were hard to follow, buried important information, and de-emphasized potential trouble. This idea, that our conversations with software's interfaces can persuade us as well as aid us is the subject of a whole area of design called *persuasive technology*, which aims to do this on purpose (Fogg 2003).

In short, the interface is among the critical stuff of game design. When we want to think about the nature of a video game, a great deal of it is bound up in the materials of the interface. Interfaces emphasize specific ideas, whether it's a preoccupation with one's health and ammunition in combat-oriented games, points in score-attack games, or something more unusual, such as the current state of one's sanity in a survival-horror game. What these interfaces privilege—and the specific forms they take—tell us a lot about the worlds we play in.

MORE?

READ: *BULLSHIT JOBS* BY DAVID GRAEBER (2019)

While *It is as if you were doing work* provides a particular framing of doing essentially pointless, white-collar computer work

in the future, David Graeber's book dives into the ways in which many contemporary jobs are already completely useless, as attested by the people doing them. Graeber, an anthropologist, is funny while exploring profoundly disturbing work environments and crystal clear while unpacking complicated chains of causation that point to, as so many things do, the undeniable flaws of capitalism.

STUDY: *VIDEO GAME VALUES: PLAY AS HUMAN-COMPUTER INTERACTION* BY PIPPIN BARR (2008)

You know what? I'm going to do it; I'm going to recommend my own PhD dissertation. In it, I focus on the role of video game interfaces—from player input to on-screen indicators and beyond—in promoting specific value systems to their players. By applying different theoretical orientations, including activity theory and Greimasian semiotics, as well as analysis of qualitative data, the thesis offers a blow-by-blow account of how video game interfaces do their thing.

WATCH: *PLAYTIME*, DIRECTED BY JACQUES TATI (1967)

Jacques Tati's masterpiece is at heart an endlessly inventive look at different kinds of work across Paris in the sixties. From the opening scene at Orly airport to the extended restaurant scene near the end, we see how the ordinary and even boring objects, tools, and techniques of work can become playful and strange again. Chairs, glass doors, building intercom systems, and more become the subjects of Tati's lighthearted but thorough examination of the real-world interfaces we take for granted.

PLAY: *PAPERS, PLEASE* BY LUCAS POPE (2013)

In perhaps the most well-known "serious game" of all time, Lucas Pope puts you in the shoes of an immigration agent at

the border town of Grestin in Arstotzka, an imaginary Eastern European country. Tasked with checking documents and stamping passports, you pass the day following increasingly Byzantine rules. Despite the game's compelling underlying plot and its multiple endings, it's really at its most interesting and revealing when you find yourself elbows-deep in its interface, fretting over a passport photo or simply lining up your denial stamp just so.

INTERLUDE

We've already come a long way, from our starting point of rules, down into the depths of computation, and back up to the glowing lights of graphics and user interface. I've described the stuff of games as concrete, and I'd even go so far as to say it does feel almost *physically present* when I work with it. Whether I'm creating and arranging the blue and gray dialog boxes of *It is as if you were doing work* or changing the rules of *Pong* via lines of JavaScript code, the materials feel as ready to hand as a well-loved pen or my laptop's keyboard.

My objective has been to emphasize just how generative and fascinating wholehearted engagement with the stuff of games can be, how it can lead to insights and understandings we never see coming. Framed by our metaphor of a "conversation with materials," care of Schön, I hope you'd enjoy sitting next to the games from the previous four chapters on a long flight. They have plenty to say about the existential joy of an infinite loop or water that's not wet.

Coming up, we're going to switch gears a little to contemplate decidedly more conceptual stuff: time, cinema, violence,

and money. Even though these materials are more abstract, I'm guessing you have the intuition already that the conversations will be no less surprising and generative than those we've had so far. And you'd be right: in reaching for these larger cultural ideas, we get to engage with the stuff of games at a different level, and to see correspondingly distinctive design considerations and opportunities revealed.

Here we go.

6 TIME: GET IN LINE

It's May 15, 2013, and I am sitting directly across from Marina Abramović, arguably the world's most famous performance artist. She's wearing a red T-shirt and her hair is in a braid over her right shoulder. The setup is not a little like experiencing her famous performance *The Artist Is Present* (Abramović 2010), except that she's on my laptop screen via Skype and we're not being completely silent—we're talking about time and video games. How did I get here? Let's rewind a little . . .

Back in 2011, I was teaching an experimental game design course at the IT University of Copenhagen. On the second day of class I spoke about different kinds of experimental art and artists, including Marina Abramović and *The Artist Is Present*. My point at the time was to get the students thinking about the broader idea of bringing an experimental mindset to their work, and in that spirit I also spoke about Marcel Duchamp, Andy Kaufman, and Lady Gaga.

But *The Artist Is Present* stuck in my head. In many ways it was an extraordinarily simple work: Marina Abramović sat in a chair in the atrium of MoMA in New York City and invited

visitors to sit opposite her (see figure 6.1). While sitting, neither the visitor nor Abramović spoke, they just maintained eye contact. When the visitor felt they were finished, they left, and the next person in line took their place. Abramović performed this work every day the museum was open, for eight hours each day, for almost three months. She sat with her silent guests for 716 hours in total.

By the end of class that day, I found myself proclaiming that I would make *The Artist Is Present* into a video game. At first this was bravado, a gesture to show the students that you could make a game about anything, even "just" sitting in a chair for a very long time. Abramović's performance is anything but straightforward, though, and my bravado was rewarded with the difficult task of figuring out how to represent it accurately.

FIGURE 6.1
Marina Abramović, *The Artist Is Present*, 2010 © Courtesy of Marina Abramović and Sean Kelly Gallery, New York / SOCAN (2022). (Image © and courtesy of The Museum of Modern Art/Licensed by SCALA / Art Resource, NY.)

What I'd thought was a "one-liner" game about doing nothing turned out to be much more than that. As I thought more about the specifics of a potential video game version of the performance, I came to realize that much of the real attraction and interest surrounding the original work is about the *audience* experience of its long duration.

Over the course of its run, more than a thousand people sat with Abramović, silently holding her gaze. One person found it so moving they returned twenty-one times. Some people sat for a few minutes, but more than one sat for hours, matching, to some small extent, Abramović's feat of endurance. Many, many people were brought to tears by looking into this woman's eyes. There was a tremendous power and tension in that time of sitting. Logistically, too, the audience experience was heightened. The work rapidly became wildly popular and slots for sitting with Abramović were in demand. Long queues formed outside the museum before opening time and there were mad dashes to get to the front when the doors swung open. People waited in line for hours, tingling with anticipation. To sit opposite a woman in a red dress.

I decided that my *The Artist Is Present* (Barr [2011] 2022b) would put the player in the role of an audience member and that it would be a game made out of time. I was thinking both about Abramović's concept of "long durational performance" and its focus on the present moment, but also the audience's time and how much of it they spent waiting. The beauty of waiting and its attendant feeling of expectation is how much it helps us experience time. I was confident that a game about time—about waiting—was a terrible idea by most metrics available to evaluating "good" game design but that just made me sure it would be a worthwhile project. Something interesting was bound to come up if I started a conversation with time

in video game form. Let's now pay a visit to the virtual Marina Abramović of that video game. Let's play *The Artist Is Present*.

The game opens outside a pixel-art version of MoMA's front entrance (see figure 6.2). The graphics are in the style of Sierra games from the late '80s. Our character is randomly generated, we're just another visitor to the museum, not a fantasy warrior or a super-soldier. When we approach the doors, a message pops up:

> The Museum of Modern Art is closed. Our hours are: Wednesday—Monday, 10:30AM to 5:30PM. Closed Christmas and Thanksgiving.

It seems we've come when the museum is shut. You see, the game keeps the same hours as the real museum in New York City, right down to taking account of the time zone and time set on your computer. This is the first indication that time here may not function in quite the same way we're used to from other video games we've played; it's a little introductory inconvenience. Oddly enough, though, I've only ever had positive feedback from players about this aspect of the game. They

FIGURE 6.2
The player stands at the entrance to MoMA at the beginning of *The Artist Is Present*.

have felt real pleasure at the idea of a game being closed, as if respecting real-world time lends more substance to the virtual world. At any rate, we'll have to wait until a little later . . .

*

We're back, having checked the day and time in New York. Now when we approach MoMA's doors, they slide open. We arrive in the ticketing hall. To enter the guarded exhibition area to the right, we need to buy a ticket. It's twenty-five dollars, but don't worry, it's just play money. As we go through these motions, we relax into a more familiar sense of video game time: we are the fulcrum of the world, and the game seems to merely wait for us to act. Now time is not so much a continuous thing but rather a punctuation of specific events: buy the ticket, greet the security guard, walk through the door. We appear to drive time forward with our own agency.

Finding ourselves in a hallway running left to right, we set off past blocky reproductions of famous artworks in the MoMA collection. *The Starry Night* and *Olive Trees with the Alpilles in the Background* by Van Gogh are in this section. We move forward at twenty pixels-per-second, feeling effective. In video games, this is another fundamental indicator of the passage of time—we're *getting somewhere*, it's time well spent. Again, time is so often measured by our ability to act. Indeed, in many games, when we stop moving, the world itself stops and waits too.

In the next section of the hallway, we see Andy Warhol's *Campbell's Soup Cans*, but we also see the back end of a queue of people (see figure 6.3). Here we come across something that is less common in play but that is in fact an iconic image of a real-world relationship to time: *waiting*, a form of time we're predisposed to dislike. This is odd, though, for at least a couple

FIGURE 6.3
The player waits in line in *The Artist Is Present.*

of reasons. One is that queues are a bit like rainbows: there's
the anticipation of something valuable at the other end, a
treasure like a renewed passport or an excellent brunch. And
another, perhaps more poetic, reason is that queues encour-
age us to experience time, to be present, much in the way of
Marina Abramović's long durational performances. Being in a
real-life queue can feel uncomfortably present indeed.

All this is in direct contradiction to many game design prin-
ciples, from avoiding repetitive and boring tasks to pursuing
flow and immersion. But principles aren't everything. Let's
venture to the head of the queue to see what the fuss is all
about. When we walk into the next screen, we realize this is
no small thing: the queue extends across the whole space, in
front of Matisse's *Dance*. There must be at least fifteen people
waiting. When we pass through to the next screen, we finally
see the front of the queue. It terminates at a white line of
tape on the floor, monitored by two security guards. Behind
the tape are two chairs and a table. One chair is occupied by

someone like you, another visitor to the museum. The other chair is occupied by a woman in a vivid red dress with a braid of hair over her left shoulder: Marina Abramović. This is what everyone is waiting for, the gold at the end of that rainbow of time (see figure 6.4).

At last! We can now put together the demand for our time represented by the queue with the reward offered by the game: sitting in a chair. We're in a video game here, a medium largely premised on entertainment value for money, so it's reasonable to think carefully about what's *worth* our time. Perhaps this is the moment to turn away in exasperation, as I'm sure many did, but then again, perhaps we can't help asking ourselves: Could it be worthwhile? This is the same question the original performance provokes, one that is partially answered by the daily queues for the experience of sitting opposite Abramović. It must be worth it after all. And so perhaps we think to ourselves, surely, *surely* the creator of this game wouldn't ask me to wait for nothing? Let's find out.

FIGURE 6.4
The destination of the queue in *The Artist Is Present*: a place to sit opposite Marina Abramović.

We retrace our pixelly footsteps, past the Matisse and all the way to the back of the queue. Setting ourselves up behind the last person, we receive a message from the game:

> You join the queue to see Marina Abramović. Now all you have to do is wait.

Waiting is often thought of as inaction, as doing nothing, but that's not what it's really like. Waiting in its pure form is feeling time passing. And boy does it pass slowly in this queue. When I made the game, I did enough research to get a reasonable sense of the rhythm of the queue as reported by the people who took part in the original performance. I learned that the average time spent by a single visitor was roughly twenty minutes but that there was a huge variance. A majority spent less time sitting with Abramović, but a handful spent far, far longer. To emulate this, the game version allocates a random amount of time each computer-generated visitor will sit from a list of possibilities in minutes:

```
private static const _sitTimes:Array = new Array(
2,2,4,4,4,5,5,5,5,5,6,6,6,6,6,7,7,7,7,7,8,8,8,8,8,8,
9,9,9,9,9,9,9,9,9,9,10,10,10,10,10,10,10,10,10,10,11,
11,11,11,11,11,11,11,11,12,12,12,12,12,13,13,13,13,
13,13,13,13,13,14,14,14,14,14,15,15,15,15,15,15,15,15,
15,15,15,16,16,16,16,17,17,17,17,17,17,18,18,18,18,18,
18,19,19,19,19,19,19,19,20,20,20,20,20,20,20,28,30,
30,30,40,50,60,60,60,70,80,90,100,120,240,480);
```

The other virtual visitors in the game might sit with Abramović for two minutes, or they might stay for eight hours. This unpredictability functions as a variable reward schedule for the player as favored by behaviorists, slot machines, and Facebook. There's an exciting jolt of action as the queue moves forward, followed by a wait for the next stimulus.

Given that we're going to be here a while, you'll probably want to occupy yourself in other ways. There's only so long you can gaze at the 68 x 42 pixels that make up Matisse's masterpiece or the hairstyles of the people in front of you. When I played through the game, I devoted an afternoon and evening to it. I watched episodes of *The West Wing*, I browsed the internet, I made an omelet. All told I waited for five hours before I made it to the front of the queue, so do keep yourself busy. This is another element of waiting and our experience of it. Unlike Marina Abramović and her laser-like focus, we inevitably feel the urge to fill the many moments with anything *except* our awareness of their passing. This is a video game that all but forces us to do other things. Thank goodness for cellphones, right? Maybe you could play *Candy Crush Saga* or something.

*

Here we are, still waiting. The queue has been advancing and we've advanced with it each time. In fact, each move forward has been fraught because there is another twist to all this waiting. I implemented the game to enforce the queue's rules. If you're not at your keyboard when the queue moves, after nine hundred frames of animation (thirty seconds) you will be pushed aside by the character behind you, and you'll lose your place. You just didn't want it enough, apparently. In the same controlling way, if you have the clever idea of repeatedly pressing the right arrow key to move forward to ensure that you'll never miss your chance, regardless of whether there's space, I have bad news for you. The game interprets this as rudely "shoving" the person in front of you. Do it repeatedly and you'll be escorted out by security.

I inserted these two small additions to the game to foreground *active waiting*. There's no easy way to circumvent the

queue or to automate it, you have to *be there*, like Marina Abramović. The effect is a hypersensitivity to time as represented by the queue. When I endured my five-hour playthrough, I was checking the game screen roughly every twenty seconds, making sure I'd never miss my chance to move up, fretting about accidentally shoving someone and getting kicked out. Trips to the bathroom were an agony of anxiety. *The West Wing* was a blur. I burned my omelet. This is another dimension to time: make it the center of your attention, tie it to something you care about, and you'll develop strong feelings about it. You'll find yourself in a bittersweet vortex of boredom and anxiety. It's as if you were wildly oscillating your way through Mihaly Csikszentmihalyi's famous diagram of "flow" (see figure 6.5), never hitting the sweet spot, only the apex and the nadir repeatedly. This is not in the design textbooks.

<div align="center">*</div>

Somehow, some way, we're here at the very front of the queue. We're next! Attempt to remain calm as the person ahead of you rises from the chair to leave. Breathe deeply as the security guard gives you brief instructions drawn from reports of the original performance (see figure 6.6):

"Hi. You're next."
"There are just a few simple rules I need to give you."
"Sit still, don't move around."
"Don't talk to her."
"Maintain eye contact the entire time you are seated."
"That's it. You can go."

Trying not to forget how your fingers work, you press the keys to navigate yourself to that coveted chair, now empty and waiting for you. I still remember the buzzing panic of this

FIGURE 6.5
Diagram of flow, adapted from Mihaly Csikszentmihalyi (2009).

FIGURE 6.6
The player reaches the front of the queue in *The Artist Is Present*.

moment in my own playthrough, the sense that something
would go wrong at this critical moment. Whether it's just
cognitive dissonance—"There's no *way* I would have waited
this long for something that's not worth it"—or whether the

experience in the queue is in some weird way transcendent, I can assure you that there *is* a deep significance here. And others I have spoken to have felt it too. Somehow, despite doing "nothing" for the last several hours, you feel exhausted and elated, ready to take your place in the pantheon of those who have what it takes: time.

You walk to the chair and sit down . . .

*

When Marina Abramović emailed me back in 2013, she reported that she had played the game herself. Could there be anything better than the thought of this epic performance artist sitting down at her laptop and guiding her character through the hallways of the museum she knows so well to join a queue to sit with . . . herself? It was music to my ears. And so was learning that she'd been pushed out of the queue because she had wandered off to make lunch. Even during our conversation on Skype, she was sautéing onions. It turns out that not everyone's cut out to wait in a queue to sit with virtual Marina Abramović. Not even Marina Abramović.

Oh, wait, did I forget to tell you what happens in the game when your turn comes to sit in the chair? I did, didn't I? Well, you know, there's only one way to find out . . .

CODA: IT'S ABOUT TIME

When I started work on *The Artist Is Present*, its treatment of time was essentially a joke: the game would be a conspicuous *waste* of time. When I was done, though, I knew time was in fact a powerful material of game design, one that led to remarkably intense experiences that could draw a player's attention to their own presence and present. It's clear to me

that this approach, design in conversation with time itself, can lead us down many new paths.

In some sense, we could say that much of the history of video game design has been preoccupied with the *negation* of the player's lived time. It's this timelessness in games, as much as any other feature, that is at the core of the idea of immersion. As Jon Dovey and Helen Kennedy (2006, 8) put it, "it is entirely commonplace that gameplay experience seems to lie outside of day-to-day clock time—we sit down to play and discover that hours have passed in what seemed like minutes." The parallels with the conditioning made use of by slot machines are pronounced. Variable reward schedules and highly stimulating audiovisuals glue people to the machine, as covered in depth in Natasha Dow Schüll's (2014) *Addiction by Design*. There are no clocks in casinos.

For an exceptionally thorough look at how time works in video games, look no further than Christopher Hanson's (2018) book *Game Time*. Hanson argues most centrally that games as a medium offer completely new ways for their audiences to *control* time. To make his case, he profiles everything from the "pause" function to games that foreground time structurally in the form of loops and repetitions. My favorite section comes in his first chapter, where Hanson offers *Lifeline* (3 Minute Games 2015) as an example of how video games are shaped for *immediacy*, "the viewer's or player's sense of an unmediated, instant, and direct experience" (21). In *Lifeline* you are effectively text messaging in real time with an astronaut called Taylor on a strange planet, with all the delays that implies. This not only absorbs you while you're in direct contact with the interface but also bleeds out into your day-to-day life. You think about Taylor's situation while waiting for another message or do some research to help her out. This

treatment of a player's time as something more expansive than the minutes and hours poured into the screen is what intrigues me most as a basis for new game design thinking.

When we turn to experimental game designers specifically, we can find numerous striking examples to support alternate forms of time. *PainStation*'s torturous extension of *Pong* welds your awareness to the here and now by literally whipping, electrocuting, or burning you back into your body (//////////fur//// art entertainment interfaces 2001). *VESPER.5* only allows a single moment of play each day, moving a monk step-by-step along a slow, months-long journey of reflection (Brough 2012). *GlitchHiker*, a game that gradually decayed and died based on players' actions, made any time with it limited, stressful, and poignant (Peel 2014). In every case, the designers worked explicitly with time to create deeply resonant play. Time is not just *spent* in these games but is acutely felt. Time is personal.

Games don't have to be about immersion in an always-on, timeless world. We have room, too, for games that wake us up to time, that push us to be present and aware in the here and now. Perhaps we should add a new hero to the video game design pantheon alongside Mihaly Csikszentmihalyi, the godfather of flow. Victor Shklovsky ([1917] 2015, 162), in his essay "Art as Device," asserts that art itself exists "in order to restore the sensation of life, in order to make us feel things, in order to make a stone stony." For Shklovsky, one way art can do this is through *enstrangement* (or *defamiliarization*), a poetic technique that draws attention to something familiar and forgotten by making it feel foreign, immediate, and possibly uncomfortable. It drops us out of autopilot.

Could games enstrange time, just as much as they help us forget it? When designers and players alike are in conversation with time, what might we learn about the world and ourselves? Marina Abramović dreamed of a dedicated institute in

Hudson, New York that would instruct visitors in her techniques for being present and in tune with their lived reality, moment by moment by moment. From walking in slow motion to lying still on a bed to watching long durational performances, it was to be a sort of house of time. And yes, I did make a video game of that, too.

MORE?

READ: *WAITING FOR GODOT* BY SAMUEL BECKETT ([1952] 2016)

If you're looking for another angle on the mesmerizing intensity of waiting, look no further than Vladimir and Estragon's existential wait at the foot of a tree. Beckett's two-act play distills waiting into something both mystical and banal. Spoiler alert: Godot doesn't show up.

STUDY: *AGAINST FLOW* BY BRAXTON SODERMAN (2021)

To dive into the ideas that swirl around video games' traditional commitment to entrancing their players into a flow state, let Braxton Soderman be your guide. He looks at flow and games through many lenses, from the historical to the psychological to the political, and problematizes the "flowing subject." Braxton starts in early. He counterpoints Csikszentmihalyi's well-known and charming story of being in flow while playing with his dog by his own story of a cat's far less friendly, but no less flowing, play with a mouse. It is seared into my mind.

WATCH: *SÁTÁNTANGÓ*, DIRECTED BY BÉLA TARR ([1994] 2019)

This seven-and-a-half-hour-long, black-and-white exploration of misery and desolation is an incredible experience of cinematic time. Take a scene such as Irimiás and Petrina walking

down a street accompanied by a whirlwind of trash. It registers with otherworldly power, in no small part *because* of our recurring and metaphorical slogs through the film's muddy fields.

PLAY: *AIRPLANE MODE* BY BACRONYM (2020)

No game has so successfully drawn me into its world while allowing me to remain alert to my own. In *Airplane Mode* you play as yourself taking a two-and-a-half (or six!) hour flight. There are no hijackers storming in or creatures on the wing, just an in-flight entertainment system, a sketch book, a virtual cellphone, and all that time to fill. Enjoy your trip.

7 CINEMA: THE *CITIZEN KANE* OF VIDEO GAMES

In the Atari 2600 video game version of the film *E.T. the Extra-Terrestrial* (Spielberg 1982), also called *E. T. the Extra-Terrestrial* (Atari 1982), the defining experience is falling into a pit (see figure 7.1). It's cruelly fitting, then, that hundreds of thousands of the game's physical cartridges were buried in a landfill in 1983. Why? It was one of the most spectacular failures in video game history. Why? It's often put front and center as the worst game of all time. Why? Well, when you play it, you keep falling into a pit, among other things . . .

But was the video game *E.T.* so terrible? In many ways it was a victim of the video game industry's voracious hunger for "sure fire" blockbusters. One strategy was to adapt already-popular movies like *Raiders of the Lost Ark* or, yes, *E.T. the Extra-Terrestrial*. Rushed to market with a development time of only five weeks, the game inevitably lacked the careful crafting of action-oriented gameplay backed by audience testing that other Atari titles had. I would argue, though, that its creator, Howard Scott Warshaw, found his way into a more truthful portrayal of the essence of the film than you might expect.

FIGURE 7.1
E.T. from *E.T. the Extra-Terrestrial* has fallen into a pit.

Yes, in the game E.T. is constantly falling into pits as he flees
scientists and government agents. Yes, the game is disorient-
ing in terms of understanding what to do, with arcane sym-
bols and unclear objectives. But on the other hand, doesn't all
that make for a more poignant portrayal of E.T.'s experience,
stranded on an alien planet, trying to get home? What if *E.T.
the Extra-Terrestrial* is a *good* adaptation of the film, and just an
unpopular video game?

The world of video games has admired the world of film
from the beginning. This has led to a long-running conver-
sation between game design and the audiovisual language of
cinema, from cutscenes to narration to fades and more. In this
sense, films are one of the key materials games are made of.
However, even video games' contemporary dominance of the
revenue competition has not been quite enough to soothe a
nagging sense that games just don't measure up. Roger Ebert

(2010) famously (and rather overbearingly) claimed that video games could "never be art," and although we can mostly laugh about it now that we have games like *Kentucky Route Zero* and *Disco Elysium*, it still hurts. What if Ebert was right in the sense that video games aren't as good at being art as cinema is?

Art has seldom been on game studios' minds in making film adaptations. From *Adventures of Tron* for the Atari 2600 to *Toy Story Drop!* on today's mobile devices, the video game industry has continually tried for instant brand recognition and easy sales via film. Sadly, the resulting games tend just to lay movie visuals and stories over tried-and-true game genres such as racing, fighting, or match 3. And the search for films that are inherently "video game-y" hasn't helped much either. In *Marvel's Spider-Man: Miles Morales*, Spider-Man ends up largely as a vessel for swinging and punching, and you certainly can't participate in Miles's inner life. So what happened to the "*Citizen Kane* of video games"?

A significant barrier has been game makers' obsession with the audiovisual properties of cinema, the specific *techniques*, rather than some of the deeply structural or even philosophical opportunities. Film is exciting because of the ways it unpacks emotion, represents space, deploys metaphor, and more. To leverage the stuff of cinema, we need to take a close look at these other elements of films and explore how they might become the stuff of video games too. One way to do that in an organized way is to focus on *adaptation*, which is itself a kind of conversation between media that inevitably reveals much about both. And if you're going to explore film adaptation to find the secret recipe, why not go with the obvious? Why not literally make *Citizen Kane* (Welles 1941) into a video game? Sure, *Citizen Kane* is not necessarily the greatest film of all time, but it certainly has epic symbolic value. Then

again, *Citizen Kane* is an enormous, complex film with no car chases and no automatic weapons. Maybe it's a terrible idea.

But maybe not! Awkward ideas are my specialty, from video games nobody can play (see chapter 3) to a game about waiting in a queue (see chapter 6), I've always found there's something to be learned from ostensibly "bad" design concepts. To that end, I decided I'd make a series of film adaptations and, to follow in the game industry's footsteps of using preestablished genres, I'd adapt them into the world of the classic Atari 2600 game *Combat* (Atari 1977). *Combat* is the quintessential action video game, pitting two low-res tanks against each other in a variety of simple arenas (see figure 7.2). The tanks groan around on their tracks, firing little bullets at each other until one or both are dead, literally spinning in their graves

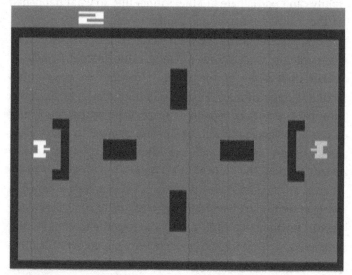

FIGURE 7.2
Two tanks face off on the classic playing field of Atari's *Combat*.

thanks to the game's odd choice for a death animation. What might the stuff of cinema have to say about that?

As for choosing the films to adapt, I figured it made sense to aim for Art with a capital A if I was looking for new ideas. I chose ten movies from the British Film Institute's list of the one hundred greatest films of all time: *Citizen Kane* (Welles 1941), of course, but also *Rashomon* (Kurosawa 1950), *Tokyo Story* (Ozu 1953), *L'Avventura* (Antonioni 1960), *Au Hasard Balthazar* (Bresson 1966), *2001: A Space Odyssey* (Kubrick 1968), *The Godfather* (Coppola 1972), *The Conversation* (Coppola 1974), *Taxi Driver* (Scorsese 1976), and *Beau Travail* (Denis 1999). These are films with significant emotional depth, complex themes, surprising cinematography, and much more. And then there's me, planning to somehow shoehorn them into the form defined by the Atari 2600 console's graphics and input limits and the fundamentally action-oriented and simple gameplay of *Combat*. I decided I'd generally focus on adapting a single scene from each movie, both because I am a development team of one and to spare any potential audience the psychological pain of playing a full tank-based retelling of every film.

Combat at the Movies (Barr 2020c) is the result of my efforts. Let's go to the movies . . .

INT—BEDROOM—NIGHT. A tank rests on a bed at the heart of a crudely drawn version of Kane's mansion Xanadu. When you try to move with the arrow keys, your tank slowly rotates in place on the bed. When you try to fire your cannon, you instead hear a gratingly synthesized "Rosebud . . ." While you're working all this out, your tank abruptly dies, spinning in place for a few seconds until the game ends.

In my adaptation of *Citizen Kane*, I focused on the iconic deathbed scene in which Kane (spoiler alert for this film from

1941) whispers the name of the beloved sled of his lost child-
hood before passing away (see figure 7.3). Take that Roger
Ebert! Choosing such an iconic scene to represent the film was
useful in a couple of ways. First, it allows a player who has seen
or at least heard of the film the chance to have that "I know
this one!" feeling. The scene is easily findable online (I studied
it extensively myself while making the game), so there's plenty
of room for the player to do a little film study before "getting
it." If there's some level of familiarity, I get a little more leeway
when translating what is dramatic on celluloid into the chunky
pixels and limited audio of *Combat*. With a little luck, some of
the poignancy rubs off on the tank version of Charles Foster
Kane as he lays dying. In short, this famous scene is *legible*.

FIGURE 7.3
Charles Foster Kane the tank lies on his deathbed in *Combat at the
Movies*.

Part of what made the design and development process of this game so interesting to me revolved around that idea of legibility and transfer, of a conversation between the game and the film. Charles Foster Kane does not, to my recollection, spin wildly in his bed to indicate his death in the film, but the tank version does, because that's how *Combat* works. And I think the tank's lonely, spinning death earns a little more pathos than usual in this inevitable end, thanks both to the weight of its isolated grandeur in the role of Kane and to its literal solitude on the game screen. While a snow globe representing his childhood home slips from the human Kane's hand on death, a single bullet is fired by his tank equivalent as a final letting go. While Orson Welles delivers the line "Rosebud" in a dramatic whisper, the tank's voice is handled by a crude approximation of the Atari 2600's rarely used voice synthesis. It sounds terrible, but it also sounds like an appropriately strained and sad last word before the end.

So my *Combat* version of *Citizen Kane*'s death scene is almost nothing like the film version, yet it has its own merits. Yes, it lacks the dramatic camera angles, clever edits, and depth of field, but it does other things quite well. Most important to me is how the *Combat* tank becomes a tragic figure instead of an instrument of play. Where *Combat* is usually about a fair fight between two tanks on symmetric terrain, here we have a single tank dying alone, filled with regret. The tank, so unthinkingly confident and lively in regular play is now stuck in bed, muttering about its memories, alone in a fortress of solitude. If the game can push us to think in these ways, to feel pity for an old war machine, then haven't we found something a little cinematic after all?

Fade dramatically to black.

EXT—COMBAT PLAYFIELD—DAY. You see the standard playfield, complete with its orderly maze of obstacles. Across from you, taking the usual position of an enemy tank is . . . a donkey? The round starts and the donkey begins ambling around aimlessly.

The heart of Robert Bresson's *Au Hasard Balthazar* is the vagaries of a donkey's life as it wanders through the human world, being treated well or cruelly in ways that must make no sense to it at all. *Au Hasard Balthazar* the video game positions you as the agent of that human world in the form of a tank (see figure 7.4). You have a mounted gun, and your most obvious first move would be to drive closer and shoot the donkey, just as you would an enemy tank. But then again, you could

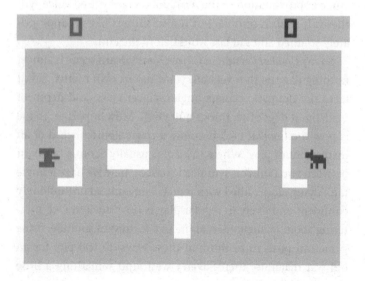

FIGURE 7.4

The donkey and the player begin their time together at the start of *Au Hasard Balthazar* in *Combat at the Movies*.

just leave it alone, letting it wander at random until it dies of natural causes, without your intervention, at the end of the thirty-second round of play.

You might shoot Balthazar because you can, or because it seems funny, or because you want to see what happens, and all these motives inspire people's cruel treatment of the donkey in Bresson's movie. You might choose to shepherd Balthazar around the screen, tending to him with affection, like Marie does in the film. You might just wander yourself, poking around the borders of the playfield and ignoring Balthazar completely. That would be very human as well. Bresson's films tend to explore these ethical decisions, in which we choose to act well or poorly, but in the film version we can only watch. In the video game, however simplistic it may be, we must bring our own human agency along for the ride and make the choice ourselves. It's a lesson that video games have relearned again and again: finding ways for the player to assume responsibility is crucial to the emotional resonance of many of the most impactful moments of play.

Fade thoughtfully to black.

INT—HOTEL ROOM—DAY. There's nothing there. Well, not nothing, but the playfield seems to be empty. There's just a blank expanse where the tanks and maze would be. Play begins and you can hear two tanks driving around, their engines growling. Time passes, and eventually shots are fired. You can hear the action, but you can't see it. Suddenly, a tank is hit, making its final sound and appearing abruptly on the screen, spinning in its death throes. What happened?

In my adaptation of Francis Ford Coppola's *The Conversation*, we deal again with a specific scene. Harry Caul (played

by Gene Hackman) is in a hotel room, listening in to a fight between a husband and wife next door that escalates to violence and finally to murder. Harry hears it all, and even sees a body briefly pressed against frosted glass, but he doesn't know what really happened. As you can see from the telling of the *Combat* version above, the game is oddly truthful to the movie in this case: there's a fight to the death, and you can only listen to it (see figure 7.5).

That core idea presented by the film of listening instead of acting is what interested me so much about this adaptation challenge. Video games, driven by the all-powerful god of interactivity, rarely allow for passivity in play: you must *do* something. And yet, listening to terrible things unfold and

FIGURE 7.5
The hidden playing field in *The Conversation* leaves the player nothing to do but listen in *Combat at the Movies*.

being unable to act is a position of intense dramatic potential. If you're not taking action, do you have more time to think? The premise of the gameplay shifts from calculating angles and timing attacks toward building a more complex narrative as you puzzle out what's happening. Leaving space for the player to simply pay attention can be a powerful way to build expectation and emotion—*thinking* is a kind of agency too. At such moments, video games and films can be in sync: both the viewer and the player, just like Harry Caul, listen and make a choice about how they think the story goes.

My adaptation of *The Conversation*, as with many of these games, goes all the way down: not only do we have a new form of (in)action in play, but the film is also written into the code. In most of my film adaptations, the player's tank is referred to as `player` and the other tank is `enemy`, but in *The Conversation* the two tanks, both controlled by crude artificial intelligence, are named `husband` and `wife` to cement their connection to the scene they play out offscreen. The program itself couldn't care less about this (I could have called them `tangerine` and `grapefruit` with no change in play), but as a programmer I find it deeply satisfying when there's a chance to align the nominally logic-only nature of code with the artistic expression it facilitates. To the extent that the code serves as the actors in the film (among other things), then perhaps we can say the code uses Stanislavski's Method, embodying its role all the way to its core. And that's not just a cute hidden detail—I think there's power in committing with a game: it means that everything matters and that you have to think that much harder about what you're doing as a developer.

As a case in point, one of the defining moments in creating this game was when I realized that my initial decision to locate a *third* tank representing the player at the top of the

screen, as though they were listening through the wall of the playfield, was misguided. The Atari 2600 can only represent *two* entities (sprites) of that kind, and those two slots were taken up by the husband and wife tanks. So the player cannot have an on-screen representative. Without a tank of their own to drive around, the player is cast literally as *themself*, listening through the walls of the playfield as the fight breaks out and spirals out of control. It's not a tank listening in, it's *you*.

Fade silently to black.

INT—APARTMENT—NIGHT. Your tank is placed on an unconventional playfield. There's just a wall and a mirror in which you can see a reflection of yourself. You drive closer to the mirror and your reflection approaches too. You press the fire button and hear: "You talkin' to me?" Again: "You talkin' to me?" You confront yourself and ask the question over and over.

The mirror scene in Martin Scorsese's *Taxi Driver* is among the most well-known in cinema history. Travis Bickle stands before a mirror in his apartment and practices for an imagined confrontation, repeatedly drawing a mechanically rigged gun from his sleeve. In the *Combat* adaptation of the scene, Travis is a tank firing off the famous line instead of his gun (see figure 7.6). In many ways, *Combat* is a perfect vehicle for the scene, with its central theme of repeated violence. The Travis Bickle tank stands in front of the mirror to psych itself up for the implied coming rounds of death struggles inherent to *Combat*, like a boxer in a pre-fight locker room.

As with *The Conversation*, the details of this adaptation go all the way down to the code. I spent a long time trying to create an accurate mirror in the game engine I was using by adding a separate camera that would show the player's tank in reverse. Eventually I gave up and went for a different kind of

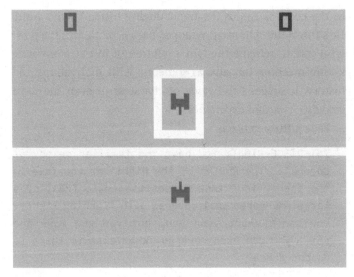

FIGURE 7.6
The tank version of Travis Bickle confronts himself in the mirror in
Combat at the Movies.

"movie magic." Instead of a second camera, I used the default
enemy tank available in my standard implementation of *Com-
bat* and placed it inside the mirror frame. I then wrote some
code so it would mimic the player's movements. What appears
to be a mirror image is a *second* tank inside the frame, perfectly
copying the player in reverse.

The fake mirror tank is referred to in the code as enemy
because that's the default. To me, this is a moment of game
development-driven film criticism. It was only by program-
ming the game in this way that I recognized how significant
this idea was to the original scene in the movie. Travis might
be imagining a confrontation with someone else, but the per-
son he's really confronting is himself. In fact, the game version
goes even further. The mirror tank, explicitly labeled "enemy"

in the code, shows us the tragic duality inside Travis's head. He's threatening himself. Wrapped back around, this is a powerful way to reframe the tank's nature not just as a one-note killing machine but also as someone with motivations and history. It suggests the value of character in even the most straightforward of experiences.

Fade grittily to black.

> INT–DISCO–NIGHT. You hear the familiar melody of Corona's "The Rhythm of the Night" as you take in the scene. Your tank is positioned in front of a large, mirrored wall covered with flashing lights. You can't shoot your gun, but you can move and spin, you can even reverse. What else is there to do but dance?

Claire Denis's *Beau Travail* ends with one of the most beautiful dance sequences in film, as Adjudant-Chef Galoup (played by Denis Lavant) dances in front of a mirrored wall. This scene follows an ambiguous moment in Denis's film in which Galoup makes his bed and lies on it holding a pistol. Does he kill himself? Is the dance sequence a transcendent afterlife, or is it just a trip to the disco? The *Combat* adaptation of the scene does not answer that question but invites the player to experience the same pleasure of dance and movement for a few moments. Here the tank can step away from the rigidly defined world of points and victory that normally shape its life into something new and joyful (see figure 7.7).

The *Beau Travail* game is the last of the adaptations in *Combat at the Movies*, and it's the most recent film in the chronologically ordered list—what a great place to end up. The *Combat* tank, a representative of military force just like Galoup, is free at last to explore other forms of self-expression.

Fade to black as the music fades out.

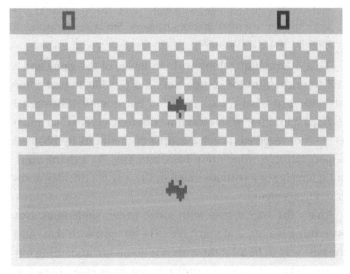

FIGURE 7.7
The final dance sequence from *Beau Travail* as performed by a tank in *Combat at the Movies*.

INT—HOME OFFICE—DAY. Pippin looks straight into camera as with a "confession cam" on a reality TV series.

Combat at the Movies was a "box office disaster." No, I didn't charge for it, so it was never going to recoup its production costs, whatever they were. Much worse, it went largely unremarked. I should have seen the writing on the wall when I showed the game to my parents (often my first and only playtesters) and they quite simply didn't "get" it. Our conversations did lead to an important addition to the game though: a menu system in the form of a classic Atari manual, allowing for a little extra exposition of the nature of each game:

CITIZEN KANE is a game of memories. Play Charles Foster Kane as he lies dying in Xanadu. Use the Left and Right Arrow Keys to toss

and turn in your bed, filled with regret. Press the Space Bar to give
voice to your one most precious memory. But better remember it
quickly! You're going to die!

That information, along with an image of the game and a
still from the film for comparison, did provide at least some
suggestion of what I was going for, but nonetheless when I
released it into the wild it was not "not well received" so much
as . . . not received. It got a couple of mentions by people I
respect (Jason Kottke, Andy Baio, and Tim W., I thank you),
but it largely sunk without much in the way of critical or audi-
ence engagement.

That's the way it goes with video games sometimes. Not
everything is a hit, and you have to be all right with that. And
the best way to be all right with it is if you get something out
of the *making*. As you can probably tell from everything I've
written in this chapter, the conversations with cinema rep-
resented by *Combat at the Movies* were incredibly interesting
from my perspective as a game designer and developer. I wrote
thousands of words in design journals as I worked. It opened
my eyes to questions about film adaptation at all levels of a
game, from the code to visuals to mechanics. And most impor-
tantly, I still feel strongly that it can be a thought-provoking
experience for willing players. From the value of committing
to grand tragedy in *Citizen Kane*, to foregrounding listening in
The Conversation, to moral ambiguity in *Au Hasard Balthazar*,
films have so much more to teach video game design than the
value of lighting and focal depth.

I like to imagine that, despite the crushing defeat on the
playfield of the market, Howard Scott Warshaw, creator of *E.T.
the Extra Terrestrial*, "the worst video game of all time," feels
the same way. He was trying to do something honest in his

adaptation, and there was a truth to it even in the face of epic, industry-destroying failure. I'm with you, Howard.

CODA: IN PRAISE OF CINEMA

As video games have ascended to a position of cultural and economic dominance in the media landscape, there has been a temptation to see film as a toppled Caesar, with video games in the role of a Mark Antony who has "come to bury cinema, not to praise it." But as game makers, we haven't yet mined the depths offered by cinema's rich history and its exciting contemporary voices. Borrowing cinema's visual language of cameras, points of view, scenes, and so on was a crucial step in figuring out how video games might be structured, but the stuff of cinema has more to say than that. *Citizen Kane* encourages us to embrace tragedy and a quiet ending. *The Conversation* shows us that listening can be more powerful than action. *Beau Travail* points toward the beauty of self-expression in terrible times. *Au Hasard Balthazar* brings the complex weight of our own responsibilities to the fore.

There's nothing wrong with an action movie or an action video game, but I suggest there's huge value in looking beyond the low-hanging fruit of punch-ups and car chases to find genuinely new cinematic forms for the games we play. I'll never play a round of *Combat* in the same way, thanks to the specter of Travis Bickle psyching himself up for his fight against the world at large. It's time to return to cinema in order to think about what video games have been and what they can be. Early attempts to adapt films into games were perhaps "notoriously bad" (Fassone 2020), but that approach remains the most direct way for game designers to have a conversation with the

cinematic medium and to come to terms with its potential. Even if we accept the idea that *E.T.* was terrible, which I don't, it was also different and new.

This is bigger than cinema, though, because we're really talking about *adaptation* as a form of video game design. While cinema (and television) is particularly well matched, all other media from theater to literature to music are teeming with ideas still untried in the youthful domain of video games. One way to fast-track experimentation is of course to adapt plays, poems, and songs. To have those conversations. There can be an air of disdain for adaptations compared to originals, but I'm with Linda Hutcheon (2012, 9) who asserts in *A Theory of Adaptation* that "an adaptation is a derivation that is not derivative—a work that is second without being secondary." As Jay Bolter and Richard Grusin (2003, 15) put it, "what is new about new media comes from the particular ways in which they refashion older media." This is all the more so when the question is how to adapt a specific work in another medium, where, as Hutcheon claims, "the act of adaptation always involves both (re-)interpretation and then (re-)creation" (7). That is, adaptation is inherently thoughtful and generative; it forces us to come to terms with the source materials in such a direct way that it can lay our design thinking bare—the conversation is loud and clear. As we've seen, choosing films outside the formulas of Hollywood blockbusters is one way to take that process of interpretation and creation a step further by exposing game design to more diverse cinematic influences.

Video games are an incredible way to explore not just the spaces we see on-screen, but also "the space of the mind" (14). When a game asks us to act as a character in a cinematic world, it can also ask us to think as that character, to weigh our choices with the same pressures and history they are

subject to. Hutcheon critiques games' adaptive possibilities on the grounds that their programming has "an even more goal-directed logic than film, with fewer of the gaps that film spectators, like readers, fill in to make meaning" (51). To me, this seems less like a criticism and more like an invitation to make that space. Quiet moments in games, as in films, may not be as exhilarating as a shoot-out, but they can demand engagement in a way that a shoot-out can't. Video games are ready for this.

The resulting games may be strange children of their film parents, but they'll be interesting children too, worth following as they grow up. Video game film adaptations will never be films, nor should they be—they introduce possibilities that not only recreate but also reimagine cinematic moments. The conversations we have with cinema through adaptation are ways to find brand new ideas for how to make games. Even the next blockbuster.

Yeah, cinema, I'm talkin' to you.

MORE?

READ: *SCULPTING IN TIME* BY ANDREI TARKOVSKY (2005)

Andrei Tarkovsky's films are not the easiest to grasp, and in this book, written toward the end of his life, he seizes the chance to explain. This is his personal guide to his major works, from *Ivan's Childhood* to *The Sacrifice*. The result is exceptional insight into why a film is the way it is from the person who made it that way. Crucially, Tarkovsky is an artist in conversation with the stuff of film, and it's apparent on every page.

STUDY: *HITCHCOCK* BY FRANÇOIS TRUFFAUT (1984)

These interviews with director Alfred Hitchcock by director François Truffaut represent one of the most thorough

explorations available of how a director thinks. Truffaut asks penetrating questions thanks to his own experience, and Hitchcock loves to talk about how his work was made. He can be a little much at times, but he sure knew what he was doing.

WATCH: *ADAPTATION*, DIRECTED BY SPIKE JONZE (2002)
Screenwriter Charlie Kaufman beautifully captures the struggle to adapt a novel into a screenplay, and it's one of a kind. Based on Kaufman's very real attempt to adapt Susan Orlean's *The Orchid Thief*, the movie gets very meta very fast. If you need a reminder of just how generative the process of adaptation can be, look no further than the story of a man destroyed and reborn through it.

PLAY: *DISCO ELYSIUM* BY ZA/UM (2019)
If there is a *Citizen Kane* of video games, I think this might be it. The epic sweep of the many interlinking stories and actions great and small make this game feel truly new and astonishing. The combination of text, voice acting, and a 3D world seems like it shouldn't work, but it does. Its protagonist, Harry Dubois, is a Kane for our video game times, and the game's soundtrack haunts me to this day.

8 VIOLENCE: LESS IS MORE

"What do we do now?"

That question, complete with quotation marks, was the theme for the 2015 edition of the Global Game Jam, an annual challenge to make an entire video game in forty-eight hours. My wife Rilla and I signed on that year in Malta and produced a game called *What We Did* (Barr and Khaled [2015] 2022). The theme inspired us to make a two-player experience that simulated the day-to-day life of a couple on the run. We broke the game into scenes based on simple actions: LISTEN, DRIVE, PRAY. Each scene featured a static grayscale drawing based on a photo, accompanied by a simple interaction: tuning a radio, driving from town to town, playing the organ in a church. The game's two players could interact via the arrow keys and the WASD keys respectively.

In the closing scene of the game, when you and your partner have chosen the action labeled "GIVE UP," you see an image of a building under construction (see figure 8.1). Each of you can fire a gun by pressing your designated keys. A gunshot rings out and there is a white flash. Two gunshots can be

FIGURE 8.1
What We Did ends with an ambiguous final scene.

triggered in total. Then nothing. What has happened? It was an ambiguous "game over" that Rilla and I argued about as we walked down to the Mediterranean at the end of a night of work on the project. Did they each shoot themselves? Did one betray the other? Even we didn't know, but we were struck by how powerful that final moment felt.

Gunshots in video games are commonplace. Violence of one kind or another, but gun violence especially, is woven into so much of game design. *Spacewar!*, from 1962 and one of the

FIGURE 8.2
Spacewar! running in emulation by Norbert Landsteiner.

very first video games, consists of two players shooting at each other in a confined space (see figure 8.2). We advance from there to present-day giants such as *Fortnite*, which consists of up to 100 players shooting at each other in a confined space (see figure 8.3).

Violence touches all aspects of game creation and play. Major technical developments have led to increasingly realistic arterial blood sprays when enemies are shot and convincing physics when bodies hit the floor. Violence often structures the larger experience of play completely, with players shooting their way through a sequence of spaces to clear them of enemies. Contemporary controllers have buttons called "triggers" for a reason: shooting is one of the more common actions

FIGURE 8.3
Bullets fly as two players confront each other in *Fortnite*.

across many genres, and shooting at the right time and in the right place is a crucial player skill. All this is framed by narratives of war, crime, heroism, and more. Violence is a very real material of video game creation.

Later in 2015, having moved to Montréal, I wanted to make a game about video game violence specifically. I'd begun to feel almost queasy about how the games I was playing trivialized or simply brushed past the implications of violent, terrible acts with the help of hero narratives, wartime settings, or cartoonish graphics. I returned to that singular moment of distilled violence at the end of *What We Did* and how uncomfortable it had made me feel. I decided to make that feeling the basis of a new game, but this time there would only be the moment of violence, unexplained by any lead-up or framing narrative. It would just be a series of gunshots. And that's what I called it.

A Series of Gunshots (Barr 2015a) is an exceptionally simple game. To some extent the biggest design decision was simply

to repeat the ending of *What We Did*. This chapter, then, doesn't retell how I figured out what the game needed to be but rather works through what a conversation with the stuff of violence might look like.

After the title screen has faded out, you're presented with a simplified grayscale drawing of an urban or suburban scene, which always features a building or house of some kind, always with windows visible (see figure 8.4). Ambient white noise creates the impression of empty streets on a quiet night. When you press any key on your keyboard, a gunshot immediately

FIGURE 8.4
A quiet suburban scene waits for player input in *A Series of Gunshots.*

rings out, accompanied by a white flash in one of the windows. Depending on a random number generator, you will be able to trigger one, two, or three gunshots before the scene fades to black and the next scene, of a different place, fades in. This happens five times before the game ends.

For me, *A Series of Gunshots* is an effort to chip away many of the elements of a traditional, action-oriented video game. I carved away complex and exciting visuals to leave a blank face. I carved away any sense of progress to leave behind just static moments, out of time. I carved away the twitches of intense gameplay to leave only a single action remaining. I carved away narrative to leave storytelling to the player. What's left is a video game that communicates through its negative spaces, and I think it has a lot to say.

Violence tends toward the spectacular in video games. You'll see the same careful attention and huge resources lavished on violent acts across diverse games, from *Super Mario Bros.* to *Hitman 3*. In *The Last of Us Part II* you can see Abby take care of zombies with a vicious choke hold. This act, repeated over and over, is lavishly rendered: from Abby's strained face as she exerts herself, to the sound design of the zombie's neck snapping, to the physics of the zombie's fall to ground. With the video game industry ever more focused on advertising through exciting trailers and striking images, visceral and immediate violence sells.

By contrast, when playing *A Series of Gunshots*, you have only the static nighttime scene in front of you, the crack of a gunshot, and a flash in a window. You don't see the shooting and you don't see the consequences. You don't know who, why, where, or when, just how: an explosion, a bullet fizzing through air. I drew each scene from photos I'd taken of

buildings and homes: apartments in Montréal, houses in Wellington, a shopfront in Ljubljana. These are ordinary places, they're everyday, often domestic. I chose these images very specifically for their neutral familiarity. There are no war zones, zombie apocalypses, or terrorist encampments to shape a righteous story of firing a gun. A shot fired in a domestic space is distressing, not diverting.

Video games are systems that structure our actions and give them a specific framing in the context of overall gameplay. In a game, violence tends to deliver progress, prestige, points. We gun down waves of Combine soldiers in *Half-Life 2* in large part because they're in our way and we need to traverse the topography of the game to make progress. We laser the aliens in *Space Invaders* for the same reasons, but also because there is literal accounting going on: we get points for each one and we want the high score. When we take down the leviathan known as an Almudron in *Monster Hunter Rise*, it's not least of all to obtain some Almudron armor. In short, violence in games is usually highly instrumental to our progress.

A Series of Gunshots has no such systems in place. There is no utility to the gunshots you trigger while playing. I implemented the randomized number of shots in each scene in part to underscore the lack of an orderly progression system. I stripped away any instrumental framing of the game's minimal action to refocus attention on the action itself and its consequences. Most of all, I wanted to remove any chance for a player to experience the repeated microdoses of success that video games feed us. I wanted to encourage reflection instead of an immersive rush of progress. The bedrock justification of video game violence, that it's how you win the game, is gone. Only the gunshot itself remains.

While skill is a feature of most video games, the role of skillful play in violent games is far more loaded. Shooting the Combine soldiers in *Half-Life 2* isn't just some businesslike procedure—it's meant to be fun and entertaining. This is especially true in multiplayer games, such as the *Call of Duty* series. The enemy soldier you shoot in the head is controlled by another player, and in some sense, you're killing *them*, which is yet more thrilling. I've heard a close friend argue that this competitive play is just an abstraction and not about violence at all. Instead, he told me, it's more a skillful dance through the geometries of a level to find the right angles and timing for success. He claimed that the fact that success in the game was an act of killing wasn't itself significant. I didn't buy it then, and I still don't. It makes no sense to claim that an abstract game in which you carefully aim at and click on (rather than shoot) various moving shapes in a geometric space is spiritually equivalent to the bloody carnage of a *Call of Duty* or the cartoonish violence of *Fortnite*. And I suspect many players would agree with me, although perhaps not for the same reasons.

Nonetheless, my friend did have one good point: skill can seem like a plausible excuse for virtual combat, making it feel more like a sport than a fantasy. My response? I omitted skillful play entirely from *A Series of Gunshots* so there is no encouragement to be found in violence well played. There's no skill to apply to your task, just your agency: any key press will trigger a gunshot, and that's all there is to it. I left causation intact, so you still fire the gun, you just don't do it well or poorly. You can't be good at *A Series of Gunshots*. What this creates space for, however, is a different sort of performance. With only the ability to control *when* each gunshot will be triggered, you're left with a form of dramatic staging. Do you

fire the first shot at once, or do you let the murmuring night linger, building suspense before it rings out? Does the second shot come immediately, hinting at professionalism or haste, or is it, too, delayed, pointing to a distinct, perhaps retaliatory, shooting? The game's minimal interactivity becomes a tool for speculation.

Storytelling is key to how many games justify the player's violent acts, so *A Series of Gunshots* has no story. In *Half-Life 2*, Gordon Freeman shoots and crowbars Combine soldiers because the Combine is trying (quite successfully) to take over the world with their own colonial violence. Freeman is justified in what he's doing, according to this narrative, because he's overthrowing violent oppressors. In the same way, underlying the ceaseless killing in *The Last of Us Part II* is a pair of intertwined stories of revenge. Add that to the standard story of "see zombie, kill zombie," and your repetitive violence is given meaning and can be, in that way, excused.

"No excuses" could have been my credo when creating *A Series of Gunshots*. In telling no clear story, the game invites, or perhaps even demands, that you imagine for yourself what has happened in the unseen rooms where the shootings take place (see figure 8.5). In contrast to the video game tradition of constantly keeping you up-to-date with what's happening and why, the game instead asks *you*: What happened? Perhaps you see, in your mind's eye, a drunk husband fumbling open a gun case and making a terrible mistake, a burglar surprised in the act, or a bullied teenager who's had enough. The game becomes a mirror for your own understanding of real gun violence, its reasons, and its consequences.

So, where does this leave us? With a game that asks us to think about why the gunshots are happening rather than tells us. With a focus on that act of imagination rather than the

FIGURE 8.5
The action happens in unseen rooms in *A Series of Gunshots*.

skillful application of force. With a lack of systems of progression that could give us easy answers based on the necessities of gameplay. With such spare representation we can't even enjoy the dubious visual pleasures of violent acts. A game that leaves us space for reflection instead of reflex.

The critic David Rudin (2015) wrote for *Kill Screen* that *A Series of Gunshots*, through its minimalism, ends up as "a relatively blank canvas onto which one can project feelings about gun-related incidents." I think this is perceptive, but not quite

the whole picture. Although I played with blankness in creating *A Series of Gunshots*, it isn't blank. From the suggestion of domestic spaces to the unpredictable number of gunshots per scene, the game does invite certain interpretations. Violence that is over quickly. Violence that happens in apartment buildings and in workplaces. Violence closer to home.

Rudin himself, understanding that the game opposes gun violence, imagines a player who is unpersuaded. This player, Rudin suggests, would simply explain away any discomfort by claiming the shots are fired by "people warding off attackers." That is as exactly the kind of response I was looking for. Individuals who "stand their ground" in home invasions might be seen as heroes by some, but their violence is very far away from what we see in video games. Reddit user P0sidon described their interpretation of the game as follows: "I think you play as a guy who goes around murdering people. Each time he murders someone he shoots him three times. In the end he realizes that this is immoral and suicides. (It only takes one shot to the head to kill yourself)" (Barr 2015b). This, too, is not your average video game narrative.

In the end, *A Series of Gunshots* is a game that creates space for players to have their own conversations with gun violence. If the stories players create through its minimalist design tend not to be triumphalist or gratifying, that's a testament to how hard it is to find something good about sudden bursts of gunfire. It *should* be hard to find a positive spin in the ambiguous darkness of the game's scenes. It takes me back to Rilla and I, walking down the hill toward the sea in the warm dark of a Maltese night, hotly debating the meaning of the final scene in our game. Like Rudin's "stand your ground" story or P0sidon's serial killer, the inevitable tension around the meaning of the shots fired gives me the sense of a new direction.

Perhaps we can start to reclaim violence from its trivialization in game design. Perhaps we can engage more deeply and truthfully with this powerful stuff. Perhaps we can find new stories to tell.

CODA: WHAT DO WE DO WITH VIOLENCE?

Violence is one of the most established and successful materials of game design. From its early beginnings in games like *Spacewar!* or *Pac-Man* all the way through to today's big studio productions like *Assassin's Creed Valhalla* and independent hits like the blade-dodging game *Disc Room*, violence has been in the foreground from the start. There's no question that death and destruction are effective ways to grab a player's attention and make them feel powerful in a virtual world. But there's so much left unsaid. Finding other possibilities in how games can work with this ancient and inevitable part the human story is important work that must be carried out in conversation with violence itself.

There's a tendency within games culture to brush off too easily suggestions that the violence of games matters. Moral panic about games, from *Death Race* in the 1970s to *Mortal Kombat* in the 1990s to whatever it is when you're reading this, has become routine; the hard thinking has yet to be done. Yes, it's true that the research on aggression and games is supremely indecisive, with some work supporting the idea of games being harmful (American Psychological Association 2020) and some negating it (Przybylski and Weinstein 2019). And yes, the establishment of the Entertainment Software Ratings Board, formed in response to the 1990s edition of the moral panics, has helped shore up concerns around young children being allowed access to the most violent games. But

none of this gets to the heart of how we might design play in relation to violence more thoughtfully and with greater range. A good start is Henry Jenkins's (2006) influential discussion of the difference between an obsession with the potential effects of video game violence versus reflection and care about its meaning. Much more recently, Amanda Phillips's (2018) nuanced examination of headshots in games also moves beyond questions of whether we're being trained to carry out violent scenarios for real, toward how they form part of a broader cultural fabric.

From a design perspective, desensitized or even dismissive responses to violence are all but built into how we play games in the first place. Roger Caillois ([1961] 2001) in his book *Man, Play, and Games* establishes a continuum between two central concepts in play: *ludus*, the principle of play taking place within fixed rules, goals, and structure that give the pleasurable sense of control and agency, and *paidia*, the freewheeling and improvisational form of play embraced by children. Both these concepts are used to defend typical violent play in games. Consider the idea of running over a pedestrian in one of the *Grand Theft Auto* games. On the one hand, you're likely to hear a player say that the game clearly *wants* them to do this, because it's implemented in the rules in the first place or because swerving would make them lose a race (ludus); and on the other hand, you'll also hear that the player is curious about what it would feel like, or perhaps whether they could hit ten pedestrians at once, like bowling pins (paidia). It's just a game after all, right? Both approaches heighten enjoyment, but also tend to deflect more challenging emotional responses to violence. I've played my fair share of games over the years and killed many, many virtual characters with a vast arsenal of weapons, all with those same

qualities of hardhearted determination and playful levity. I'm
ready for something else.

Let's start by accepting our responsibility as players to chal-
lenge ourselves, even if our games won't. We can have our own
conversations with the violence of video games through play.
Consider voluntary "permadeath" playings of games (Keogh
2013a), in which a player agrees to the new rule that they
will stop playing a game entirely if they die. This enormously
intensifies all violent acts in play by restoring a sense of risk
and mortality to each moment. Various games have sought to
fold this spirit of play into their rules with some success, from
DayZ's literal permadeath to the punishing grind of *Dark Souls*,
making them a more consequential experience of violence.

I'll end with a hopeful note care of my game design idol,
Robert Yang. There are seeds of something very powerful in his
game *Hurt Me Plenty*. In it a violent act—striking someone—is
reframed by the intimate and erotic world of BDSM. Yang's
decision to have a cool-down period for the virtual partner to
recover is both tender and an acknowledgment of the physi-
cality of the act. Crucially, it's not just that violence has been
moved from the battlefield to the bedroom and recontextual-
ized away from guns and gore. It's also that it's a conversa-
tional approach to violence rather than a declarative one. It
leaves space for us to speak and act and for the violence that is
in all of us, in one way or another, to talk back.

MORE?

READ: *MILKMAN* BY ANNA BURNS (2019)
Set during the Troubles in Northern Ireland, Anna Burns's
Booker Prize-winning novel is centrally about violence with-
out having it literally played out on the pages. Rather, violence

permeates every conversation and threatens at every street corner. At the same time, the book and its protagonist "middle sister" are endearing and hilarious. Quite a trick, a comedy goldmine in the mountains of strife.

STUDY: *KILLING IS HARMLESS* BY BRENDAN KEOGH (2013B)

Written as a book-length analysis of the game *Spec Ops: The Line*, *Killing is Harmless* will show you just how much a sharp mind can take away from what is a straightforward game. From detailed analyses down to the level of the quotations on loading screens and up to big-picture thinking about games as self-reflexive genre critiques, Keogh puts on a masterclass of thoughtful play that is often on my mind.

WATCH: *THE ACT OF KILLING*, DIRECTED BY JOSHUA OPPENHEIMER (2012)

In this hard-to-watch documentary, perpetrators of mass killings in Indonesia speak candidly about their crimes against alleged communists and even restage them. In a particularly dark scene, one of the killers talks about his ingenuity in constructing a more efficient means of murdering people, caught up in the mechanical details of the apparatus. It's an unforgettable meditation on violence from the perspective of some of its most terrifying agents.

PLAY: *PROBLEM ATTIC* BY LIZ RYERSON (2013)

In *Problem Attic*, a psychological platformer, Ryerson puts us in a world that vibrates with its violent rejection of our very presence. Everything we try to do is almost impossibly difficult, as platforms shudder us off and garish colors and occlusions make us lose our way. I promise you'll feel more shaken by this than by any virtual shooting gallery.

9 MONEY: ONE EASY PAYMENT OF $4.99

In May 2021, I bought the Sahara Desert. Well, not the actual desert, but a 3D model called "Sahara Desert Landscape" (Black Sun 2016). It cost US$4.99, and when I loaded it up on my screen I was very impressed by its undulating dunes, the meticulous detail of the tiny rippling waves of sand, and the way the light threw shadows across it all (see figure 9.1). It did have its flaws, like being merely one square kilometer and clipped brutally into a literal square at its edges, but that's par for the course. Overall, I think, it was a pretty good deal. So began my conversation with that crucial stuff of games: money.

Everything costs something to make, and this is as true in video games as anywhere else. Whether it's a modeler creating the perfectly barren tree, an animator making it sway, or an environment artist positioning it *just so* in a post-apocalyptic backyard, the spirit of money hovers nearby in the form of hourly wages, rent, equipment, and electricity bills. When we buy a game, these production costs are largely invisible to us except when, for instance, we hear that a game such as

FIGURE 9.1
Sahara Desert Landscape by Black Sun, as seen in *v r $4.99.*

CD Projekt Red's *Cyperpunk 2077* cost around $175 million to make (Kiciński 2021). Even so, figuring out how that vast sum is distributed at the level of individual elements of the game is out of reach. How much did that flying car cost to put in? What about that neon haircut?

I bought the Sahara Desert from the Unity Asset Store, an online marketplace through which creators can sell everything from landscapes to music to explosions. That's the meaning of *asset* in this context: a specific element, such as a 3D model, a sound file, or a particle system, used in the creation of a video game. Of course, *asset* also has a more common connotation: it's about money, baby. Assets are worth something and, on the Asset Store, although there are some free assets, most cost money to buy. This makes for a very useful way to think about money in the creation of a game. Unlike a player, who can't know how the costs of a game are allocated, a developer buying assets on the Asset Store knows those figures down to the cent. Further, the commitment of cold, hard cash is a great

motivator for closely examining those assets and evaluating them: there's a lot more riding on the trees that make up a forest if you're purchasing each one individually, with your own money.

I'd been wanting to return to the idea begun in *v r 3* (see chapter 4) of a video game that exhibits items from the Unity Asset Store. In *v r 3* I had been most interested in contemplating water assets for their own sake, but inevitably the cost associated with some of the waters colored how I and the game's players thought about it. While it's relaxing to gaze at ripples gracefully stirring the surface of a pool of water, it's hard not to dive into conversations about labor, value, the marketplace, and more when you find out some water cost $22.99. Is it worth that much? I intended my new game, set in a desert, to focus on the ways in which money is a material of game creation and what a conversation with it might tell us about games.

I thought initially that I'd present a series of assets from the store at different price points: a one-dollar asset, a two-dollar asset, a five-dollar asset, and so on. With time, however, I came to think that the best way to encourage the contemplation of assets and their costs was to select things that all cost the *same* amount of money. If every asset costs the same, we can start investigating the reasons why that price was set. It turned out that the *minimum* price for a paid asset on the store was $4.99, so I decided to name the game *v r $4.99* (Barr 2022).

v r $4.99 presents an "art park" in the spirit of the Chinati Foundation in Marfa, Texas or the Storm King Art Center in Windsor, New York. We're looking at a desert populated by assets from the Unity Asset Store, each costing $4.99. It's also like a showroom or a very meta "dollar store" filled with diverse objects you could buy for just under five bucks. Every

asset is accompanied by a plinth detailing its title, artist, year of creation, and other information. My park provides a place to reflect on money and the conversations about value, commerce, and goods it can lead to.

How about you and I take a walk through this stretch of the Sahara Desert and visit some of the artifacts strewn on its sands?

What's that light over there? It's a sign! No, really, the first thing we can see from here is a pair of classic roadside signs with lit-up arrows and space for three lines of text (Bogers 2017). They're the sort of thing you might see outside a Dairy Queen or a bingo hall (see figure 9.2). These two read, respectively: "A CUSTOMIZABLE ROADSIDE SIGN" and "WITH BLINKING LIGHT ANIMATION!" What does the information plinth have to say?

> Customizable Roadside Marquee Sign
> Dustin Bogers
> 3D
> v1.0, 6 October 2017
> 16.47 MB
> *Create eye-catching roadside advertising for your scenes with this asset!*
> $4.99

Immediately, questions about comparative value come to mind. Compared to an entire square kilometer of desert, are these signs a good deal? They certainly think so themselves, but they're so *small* compared to the desert. On the other hand, they do have an explicit function and they even have a *BLINKING LIGHT ANIMATION!* There are only two here, dwarfed by the dunes, but that's because when I installed them, I followed Dustin Bogers's presentation format as reflected in a "demo

FIGURE 9.2

Customizable Roadside Marquee Sign by Dustin Bogers, as seen in *v r $4.99.*

scene" that came with the asset. My curatorial principle while making the game was to try to present the assets as I imagined their maker would want, in their best (blinking) light. I could have put a hundred or a thousand of these signs in my park and perhaps raised further questions about the value of quantity in the context of completely virtual goods. There were many more assets to install, however, and there was only so much desert, so two was enough. Let's leave the signs where they are, cheerfully advertising themselves.

Moving right along . . .

Over there we can see two columns of animals confronting each other on the ridge of a sand dune (see figure 9.3). To the right are realistically modeled and textured animals. They're even animated: the two elephants at the head of that column trumpet soundlessly with their trunks and turn their heads to the side repeatedly. To the left we have a line of less detailed, more cartoony animals. They're standing stock-still in place,

FIGURE 9.3
Left (background): Low Poly Rigged Animals, by TheLaba. Right (foreground): Animal pack deluxe v2, by janpec. Both as seen in *v r $4.99.*

led by a giraffe, a bison, and then the essential elephant. The two plinths here tell us that we're looking at "Animal pack deluxe v2" (janpec 2019) and "Low Poly Rigged Animals" (TheLaba 2018).

Here we have a direct comparison between two asset packs from the same Unity Asset Store category (3D > Characters > Animals), each costing $4.99. In a way we could say they're the same: a collection of animals. But we've already seen many distinctions between them that provoke comparisons. At first, we may be tempted to say that the deluxe pack of animals is clearly better value for money. Its animals are more complex (with more vertices), they're animated, their textures are at a higher resolution, and the pack has three elephants instead of just one. On the other hand, the low poly animals are low poly for a reason: they offer a distinct visual style that's been popular for some time now (consider *Virginia*, say, or *Outer Wilds*). If I were making a low poly game to follow that trend,

buying a realistic elephant would be a huge mistake, regardless of cost. Even if it also came with a camel, a cat, and a Komodo dragon (which this one does). The rationale for buying an asset is informed not only by the stats of its polygons and textures but also by its relationship to the actual game we're trying to make. No use buying a high-res cat for a low-res world.

Full disclosure: "Animal pack deluxe v2" isn't in the version of *v r $4.99* I finally released in late 2022. In fact, you and I are wandering around in an earlier version I was working on while first writing this chapter. When it came down to it, "Animal pack deluxe v2" had one extra quality that wasn't so desirable: it was enormous, weighing in at 729.1 megabytes. From one perspective, that's a lot of value for the money, but in my efforts to make the game smaller to download for potential players, I had to remove a couple of the larger assets, and the high-resolution animals didn't make it. I replaced them with a different pack called "Voxel Animals (#23)" (GBAndrewGB 2018) which came in at a svelte 217.8 kilobytes. Sometimes you use money to buy what you need, not just what you want.

Let's move on from this menagerie. Follow me . . .

Quick, run! There are giant spiders crawling toward us over the next dune! No, wait, they're not actually moving, they're just standing there waggling their abdomens rhythmically. This, according to the nearby plinth, is the "Egypt Pack—Spider" set of assets, described as being "designed with marvelous hand painted texture as well as high-quality rigged and animated [sic]" (Openlab 2020). The spiders loom threateningly in place like a set of scary kinetic sculptures that cost $4.99 (see figure 9.4).

These arachnids worried me initially. The question of cultural appropriation reared up, perhaps triggered from having seen

FIGURE 9.4
Egypt Pack—Spider by Openlab, as seen in *v r $4.99.*

so many "hat packs" that inevitably included the terrible idea of an "Indian Headdress." Buying the spiders felt like it might represent an endorsement of something I didn't believe in. Money sharpens these responses, I find. From a little research, it wasn't clear from the Asset Store or their website whether the creators, Openlab, are an Egyptian studio. Still, after some discussion with Rilla, I went ahead with them. Whatever the credentials of their creators, the spiders remain emblematic of a specific kind of character design in video games. A conventional idea—a series of increasingly challenging enemies—is dressed up in a "cultural skin." And there's no question these spiders are intended to fit into a conventional game design: they have names like "Boss" and "Elite" and their animations include "attack," "hit," and "die." So I was paying not just for the immediate visual impact of giant spiders but also for their ability to fit seamlessly into a certain kind of gameplay model.

Let's leave those spiders be for the moment and make our way over to one of my favorite installations . . .

FIGURE 9.5
Humanoid Creatures Pack by Maksim Bugrimov, as seen in *v r $4.99*.

Here, on a little rise in the sand, is Maksim Bugrimov's "Humanoid Creatures Pack" (Bugrimov 2020), a row of five very creepy, nameless monsters dancing their hearts out like they're auditioning for the next *Magic Mike* (see figure 9.5). Well, really they're running through the impressive forty-one distinct animations they come with, from attacks to deaths to jumps, but in sequence it looks like a cheerfully ghoulish cabaret. They're impossibly charming, and I knew I had to have them. Yes, the purchase was an impulse buy, but sometimes spending money is allowed to be fun, right?

Bugrimov's humanoid creatures demonstrate another key function of money in this video game context: paying someone for their work. As I scanned the Unity Asset Store's entire collection of 3D assets, I ran into Bugrimov's 3D models many, many times. By my count, he has over 270 assets listed on the store, from "Stalin Statue" to "Dead Man in the Bag." Of all the creators I've seen in the store, Maksim Bugrimov is my favorite, and, for me, that adds further value to his assets. He's

my guy. And, of course, those monsters stole my heart when I saw them. All five were doing their "dance" in a promotional video, starting with some deep breathing and then suddenly launching into twists and arm waves that were inescapably joyful. Take my money, Maksim.

Leaving those beloved Chippendales behind, let me introduce you to a couple of guys I'm less enamored of . . .

Meet "Prisoner-01" (Astronaut 2018b) and "Prisoner-02" (Astronaut 2018c), two orange-jumpsuited men standing side-by-side, each behind his own plinth (see figure 9.6). They're running through a more or less matching series of animations in a loop that ends with their death and resumes with them leaping back to their feet. Prisoner-02 has a bit of a rounded belly, Prisoner-01 is completely bald, but we might feel inclined to say that they're essentially the same, or at least minimally different from one another. Nonetheless, each man cost me \$4.99. Indeed, they're part of a series of twelve prisoners

FIGURE 9.6
Left: Prisoner-01 by Astronaut. Right: Prisoner-02 by Astronaut. Both as seen in *v r \$4.99.*

(imaginatively named Prisoner-01 through Prisoner-12), each of which can be purchased for—you guessed it—$4.99.

Now, in truth, there's also a "Prisoners Pack" (Astronaut 2018a) that collects all the prisoners together for $14.99. I bought Prisoner-01 and Prisoner-02 separately to illustrate another quality of an online marketplace like the Unity Asset Store: the role of marketing and borderline predatory selling. In listing every prisoner individually for $4.99, Astronaut helps to make the Prisoners Pack look like a deal, a grand savings of $44.89 over individual purchases. This gets at the sheer arbitrariness of pricing: assets cost whatever the creator determines. Further, for someone browsing the store, there's no guarantee they'll discover the pack before the individuals, which may lead to some regrets. Finally, the prisoners, in my opinion, aren't great. Their legs have more in common with Gumby than humanity, and their faces are more like that of a terrifying robot hotel receptionist than a living person's. So, another lesson learned, this time for *two* easy payments of $4.99: buyer beware.

As we walk on, let me tell you another little story . . .

You know, buying the prisoners *wasn't* easy. After I bought Prisoner-01 and was excitedly going through the series of clicks to buy Prisoner-02, already cackling about the hilarity of seeing both of them in my game, I ran into an error. The system reported that I couldn't buy Prisoner-02 and gave me a reference number for follow-up if I wished. I tried a few more times, but the error remained. I eventually got in touch with Unity's help desk, who told me that the error signaled that the purchase was being blocked by my bank, presumably flagged for credit card fraud. I contacted my bank to sort it out and they promptly told me the problem was on the Unity side. The two corporations bounced me back and

forth, neither accepting responsibility. Eventually I paid for Prisoner-02 (and every subsequent asset) with PayPal to avoid the issue. It's possible that I appreciate these unsavory characters even more for the unsavory consumer experience I had buying them.

Well, while we were talking, we've reached the last asset I wanted to show you. Let's take a look . . .

Here's the plinth, telling us we are viewing "Seagull (Larus canus)" (Suko 2018). In front of the plinth is a pedestal where the seagull has been placed. Except . . . it's not there (see figure 9.7).

The seagull is a complex character. When I bought it (for $4.99), I followed my usual process of placing it in a suitable location in the desert and then running the game to take a look. It turned out, however, that by default the seagull was designed to be controlled by the same keys that I had designated to control the player's movement. This led to a doubling

FIGURE 9.7
The plinth where Seagull (Larus canus) by Junnichi Suko would be if it hadn't walked away, as seen in *v r $4.99*.

of agency: you'd be playing as yourself, but you'd also be the seagull. I responded with a few awkward design ideas. I thought about having special instructions encouraging my player to toggle between controlling their own viewpoint and the seagull's. I thought about locking the seagull into a confined space, like one of those flipping toy dogs on display. I thought about removing the interactivity altogether and just programming the seagull to walk in circles on its pedestal. But each approach ultimately felt like it devalued Junnichi Suko's work in creating it.

In the end, Rilla came to the rescue. Her advice? Just let the seagull be itself. Now, when you begin the game, the seagull is there on its pedestal, unseen by you because it's far away from your starting point. As you walk around, however, the seagull is under your control, walking and perhaps even taking flight depending on the keys you press. By the time you get to its pedestal, there's very little chance it will still be there. It'll be somewhere else, thanks to you. I like this a lot because it puts a key piece of the money puzzle in place. The unassuming seagull earns some significant part of its price point from its interactivity, that sacred property of video games. It's made, in part, of code, and that code is worth something. Put another way, the seagull is a reminder that much of the value in a video game is in the *experience* it generates, and this is true at the level of individual assets. For me, being able to create the experience of searching the desert for a tiny seagull you're simultaneously controlling was worth paying for. You're welcome.

We're almost at the end of our tour, but let's take the time to talk about something that's not here at all . . .

When I was starting this project, one of the very first assets I set my sights on was the complex and sophisticated

"cyberpunk—Cyber Room" (IL.ranch 2020). I fell in love with it. It's a single interior space filled with cathode-ray tube displays, an office chair, a rug, lights, books, and much more, all very *Bladerunner*. It's an evocative place, and a truly impressive amount of work has clearly been put into it. A steal at only $4.99.

So, when the time came to start installing assets, the Cyber Room was the first thing I went to buy after the desert. Except by then it cost $5.55, not $4.99. Only fifty-six cents more, but that was an uncrossable chasm for a game called *v r $4.99*. I couldn't buy it. Later on, it jumped up to $19.99 before resettling, as I write this, at $5.55 again. I'd still say it was worth it the whole time, especially in comparison with some of the other assets around (I'm looking at you, Prisoners 01 and 02). Perhaps that's our final lesson from the market for today. Value as reflected in pricing is neither objective nor consistent, especially as creators can change the price of their work with a few clicks. They're welcome to charge what the market will bear or to motivate customers with a sudden sale. The Cyber Room itself hasn't changed; it's still out there, buzzing with potential, calling to me with its appealing, synthetic voice . . .

CODA: FOLLOW THE MONEY

Games are, in a sense, "made of money" in that every part of them costs something to create. Thinking about the value asserted by this cost is, as we saw in the case of *v r $4.99*, a powerful way to focus our attention on the ways games are made, from a financial decision to "go low poly" to buying the code that makes a seagull fly. Money is among the stuff of video game creation, and money talks.

Following the money isn't only a matter of costing out video game assets—think of the amount of design work around the *player's* money represented by free-to-play games (Paul 2020) or the delicate balancing of the little gambling machines that are loot boxes (Brady and Prentice 2021). For that matter, think about the political and economic implications of distributing games *without* a financial element. Here, too, we'll find that conversations with the underlying monetary nature of video game design lead us down crucial paths to understanding what's going on under the hood.

Still, I'll confess that breaking a game down into its component parts, creating an itemized accounting of the overall work, is where my mind goes. As Stefan Werning (2021, 58) notes in *Making Games*, "creating an economy for game assets in itself frames digital games as collections of parts rather than an integral whole," at least in the eyes of the developers perusing that vast trove of stuff. We pick and choose spaceships and trees and dinosaurs and more, putting them together in our own way to create new work. Design by marketplace. Werning goes on to suggest this can be problematic, leading to designs that are mere assemblies of disparate pieces or that feature overused default effects such as lens flares, but he also sees an opportunity to leverage the components-first approach to design. He connects it with the rich potential of remix culture and recommends that "a critical exercise . . . might be to consider ready-made assets in the tradition of found footage, in the artistic sense as détournement or with reference to more contemporary digital video remixing practices" (61).

One person who's been exploring that exact path with incomparable sensitivity and flair is David Kanaga, a musician

by trade but also the creator of the video game (or "dog opera," in his terms) *Oikospiel Book I*. *Oikospiel* is multifaceted, but central to its nature is *collage*: Kanaga built the game using the same central repository of assets as *v r $4.99*, the Unity Asset Store. In doing so, he used the pleasures of consumerism almost as a game design methodology. As he told Jesper Juul in an interview: "When I got down to working on it, I was using the Asset Store, playing the role of a happy capitalist, thinking, 'Oh, I need a new scene, so I'm just going to go buy it. And I want more stuff in.' And it was all just piling on, excess on excess" (Juul 2017).

Already highly attuned to political philosophy around capitalism, Kanaga noticed that in parallel with the freewheeling, free-market experience of buying whatever he wanted, he was "also working very hard, and resentful of some of the tasks I set myself. I found myself trying to occupy both roles, playing both Capital and Labor" (Juul 2017). *Oikospiel* ends up as a genius jumble of assets interrogating what it means to *buy* a game as you make it.

Whatever we think about the outsize impact of money on video game design and development, it's a fact. Whether ambling through a sunny desert looking for a seagull or running along a beach as *Oikospiel*'s dog, we can feel the stuff of money all around us.

MORE?

READ: *JR* BY WILLIAM GADDIS ([1975] 2012)

I'll confess it's not the easiest book to read in the world, but William Gaddis's *JR* is a hilarious satire of the capitalist dream of a world made by and for money. Sixth-grade student JR starts out trading with his classmates, proceeds to buy penny stocks,

and ends up as a financial Goliath. The writing is fast and funny throughout, and the jokes about money keep on coming.

STUDY: *GAMES OF EMPIRE* BY NICK DYER-WITHEFORD AND GREIG DE PEUTER (2009)

If you want to zoom out on the enormous question of video games' myriad relationships to global capital, you still can't do better than Dyer-Witheford and de Peuter's classic text. From the perspectives of workers at corporate giant EA Games to a deep dive into activist approaches to play and game design, this book is brimming with new tools for thought.

WATCH: *THE SHOW ABOUT THE SHOW* BY CAVEH ZAHEDI (2015)

There are many reasons to enjoy *The Show About the Show*, but best of all is its premise that each episode is a "making of" of the previous episode. It has a postmodern flair I love, and Zahedi himself is alternately deeply charming and deeply problematic. It's also all about money: the money Zahedi always needs to make his works of weird genius. Zahedi brings us along to funding pitches, gets onto Kickstarter, and more, as he wields the complex and expensive apparatus that is a TV show.

PLAY: *SLOTOMANIA* BY PLAYTIKA (2011)

Perhaps nothing evokes the raw energy of money so much as playing a slot machine. Money goes in and (sometimes) money comes out. *Slotomania* tries to recreate the intensity of a casino on your phone or computer, but it does so while blurring the meaning of "money" altogether. Is it the virtual coins you feed into the slot machine, the gems you can spend on exclusive features, the real money you can use to buy both? All of the above? Be careful in there.

10 CONCLUSION: HAVE YOU SEEN THE MOON TODAY?

In 2011, I made a game about the meaning of life called *Guru-Quest* (Barr [2011] 2021). The player wakes up in a cozy little house in a forest, goes outside, and walks to a pagoda nearby. In the pagoda is a guru. Using their keyboard, the player can talk to the guru about anything they want, from deep, existential topics to that week's baseball scores. I think it's a fitting game to conclude this book with, given that it involves a *literal* conversation with a video game.

The original game was created a long time ago, in technology terms. I used software called Processing that works on top of the programming language Java, but the various operating systems have moved on and the applications I created back then no longer work on my computer. Worse, during one of my several catastrophic data losses over the last decade, the source code for that version of *GuruQuest* was lost. All I have left is a nonfunctional application sitting on my computer.

When I began writing this concluding chapter, *GuruQuest* was still defunct. But while mourning its loss all over again, I realized that, wait, the stuff *was* still there, inside the old

application! I opened the application "package" and extracted the .jar file that represents the compiled Java code. Using software called the Java Decompiler, I turned that file into the original source code, sound files, and other elements that made up the game. Perhaps most importantly, I could then retrieve the guru's "brain": a text file containing the rules that determine how the guru responds to the player's input. In a real "brain in a vat" moment, I wired up the guru's brain in JavaScript and created a simple interface to talk to them.

So, let's have a quick chat . . .

Pippin: I think I might have finished my book . . .

Guru: Beginnings.

Pippin: You're right though, this is only the beginning . . .

Guru: This is the only world we have.

Pippin: It's true, and we should pay attention to what we find here. Even video games.

Guru: Are all things made of ash?

Pippin: No, they're made of myriad, beautiful, strange stuff.

Guru: Do you hear the wind in the trees?

Pippin: I'm listening . . .

Video games are made of all kinds of stuff, and *GuruQuest* is no different. From its Java code, to sound files of me playing the ukulele, to my early attempts at procedural graphics using Perlin noise, the game is another example of the diversity of game stuff. The guru's "brain" is a script that works with perhaps the central material of the game, Joseph Weizenbaum's (1966) ELIZA chatbot. Each of these components contributes to the experience and meaning of *GuruQuest*, but they do so more or less invisibly unless we pay attention, unless we *talk* to them and *listen*.

It's only in this way that we can come to grips with how the Rogerian psychotherapist that ELIZA was modeled on became a somewhat clichéd guru. The script of rules for ELIZA was edited to focus on, you know, "guru stuff." Instead of responding to a statement about a dream by saying, "Do you believe that dreams have something to do with your problem?" the guru's script is altered to emphasize ambiguities such as, "There are many dreams, few realities." The game itself rests on the stuff of conversational rules and how the player encounters and plays with them.

*

I hope you're convinced by now that the stuff games are made of matters and has always mattered. That the elements of a game speak about and can reveal deep insights into the nature of design and play. That a game designer is, as Schön puts it, in conversation with their materials. While the more commonplace idea of a video game as a total, seamless package is attractive, I think it may be more accurate to say that in many ways the parts are greater than the whole. If we're talking about design, then the stuff is where the meaning is, it's where the fingerprints and doubts and decisions of the designer live. The stuff is the lively conversation partner that collaborates with and provokes us to make a game what it is.

Throughout this book, we've run into many examples of the revelations and inspirations that are possible when we take our conversations with the stuff of video games seriously. In the earlier chapters we got to know key, concrete parts of games. Turning off collision detection for a *Pong* paddle made us ghostly and vulnerable. We established a relationship of empathy with the very circuitry of our machines through the travails of a low-resolution Sisyphus. We saw that virtual water

is no longer just set decoration but a sparkling and sophisticated technical achievement worth gazing into for its own sake. The dialog boxes, sliders, and date pickers of our day-to-day work are also the stuff of play that speculates on a possible future.

In later chapters, we stopped thinking about the stuff of games in such a literal sense and instead turned our attention to more conceptual elements. *The Artist Is Present* reached out through the screen to situate us in our own time-sensitive bodies as we waited in a queue for hour after hour. Through the lens of cinema, we saw that a *Combat* tank can become Travis Bickle from *Taxi Driver*, threatening itself tragically in a mirror. We felt the weight of violence through the sudden sound of a gunshot and the silence in the grayscale streets after it has faded away. And we saw how by spending a little money, just $4.99, we can build an appreciation for the value of all the little things that make up our games, all those monsters, supermarkets, and seagulls in the Sahara Desert.

*

It's time for me to let you go. It's your turn to pick up the conversation. I believe strongly in this approach to understanding the strange, often awkward, sometimes embarrassing, always fascinating world of video games. To really, truly get a feel for it, though, you'll need to be the willing voice and the listening ears yourself. In fact, just as much as I've tried to show the value of being a reflective practitioner in game design, I think it's time we started thinking about *play* as a reflective practice in Schön's sense too. As players we sit right in front of the stuff games are made of, and it's dying for a chat.

In that spirit, I want to offer you one last set of recommendations, this time not for media with which to fill your

thoughts but for activities to develop and express your own perspective as a player.

Write a detailed description of one object in a video game you've played. It could be anything: a mine in Microsoft's *Minesweeper*, a candy in *Candy Crush Saga*, or a dwarf in *Dwarf Fortress*. For that matter, don't limit yourself to the objects presenting themselves front and center; what about a tuft of grass swaying in the virtual breeze in *Red Dead Redemption 2*? Try to evoke everything about the object: the way it looks and the sounds it makes, the connotations of its colors and the implications of its use, the way it fits within the larger systems of the game. Get to know it deeply. Once you've got about 500 words, get someone you trust to read it and start a conversation.

Teach someone you love about the most evocative game rule you know. Is it *Monopoly*'s "go directly to jail"? Is it the ever-shrinking arena in *Fortnite*? Is it the required cooldown period after a consensual spanking in *Hurt Me Plenty*? Try to explain not just how the rule *works*, but also how it's in conversation with the entire game, how it's one of many lynchpins that make the game what it is. Consider going all in on a PowerPoint presentation, complete with screenshots and videos, references to related rules in other games, and analysis of the sociocultural context the rule was invented in. Once you get started, I think you'll find there's a lot to say.

Record (or stream) a "let's play" video and take your viewers on a walking tour of your favorite video game environment. Get a hold of some screen (and audio) capturing software, such as OBS, and follow one of the many tutorials aimed at people starting out on Twitch. Fire up the game, get to

your location, hit record, and start talking. Imagine you're taking a friend for a walk in your local neighborhood. Point out the sights and ignore the demands of gameplay in favor of contemplating the world itself. Take them to a forest in *The Legend of Zelda: Breath of the Wild* and look at the trees. Show them *Kentucky Route Zero*'s gas station and marvel at the giant horse's head, the gas pumps, and the distant headlights of cars. If you dare, put it out there and find out what other people think.

Finally, you probably already know that I still feel like there's no substitute for getting your hands dirty with a few pixels and snatches of logic. To really grapple with the stuff of games, you'll need to make your own . . .

Make a tiny video game using Adam LeDoux's perfectly self-contained game engine Bitsy. You don't need to know how to program anything. Draw a room or a castle or a canyon or a street. Make little objects like cats and crayons and crêpes. Put them all into your game. Add text descriptions so that a player can bump into the stuff your game is made of and so it can talk back. Recreate your bedroom, make a Mars base, set up a disco. And while you do it all, try to remember you're a reflective practitioner: stop and think about the nature of the tool you're using, the pixels you're combining, the texts you're writing. Think about what they say to you, both together and apart. Have your own conversation with the stuff your game is made of and then, when you're ready, ask a friend to play it and start another kind of conversation. And then keep going.

I hope it goes without saying that I'd love to read, watch, and play the results of your future conversations with the stuff

of video games. I'll be over here, talking with my own games. And listening, always listening.

In that spirit, let's leave the final word to the guru . . .

Pippin: Any final words?

Guru: Have you seen the moon today?

REFERENCES

3 Minute Games. 2015. *Lifeline*. iOS. 3 Minute Games. https://www
.3minute.games/.

Abramović, Marina. 2010. *The Artist Is Present*. Performance. https://
www.moma.org/calendar/exhibitions/964.

Activision. 1985. *Little Computer People*. Commodore 64. Activision.

———. 1986. *A Computer Owner's Guide to the Care of and Communi-
cation With Little Computer People*. Activision. https://archive.org
/details/LittleComputerPeopleManual1986AppleIIC64.

American Psychological Association. 2020. "APA Resolution on Vio-
lent Video Games: February 2020 Revision to the 2015 Resolution."
https://www.apa.org/about/policy/resolution-violent-video-games.pdf.

Antonioni, Michelangelo, dir. 1960. *L'Avventura*. Columbia Pictures.

Astronaut. 2018a. "Prisoners Pack (version 1.0)." https://assetstore.unity
.com/packages/3d/characters/prisoners-pack-107788.

———. 2018b. "Prisoner-01 (version 1.0)." https://assetstore.unity.com
/packages/3d/characters/prisoner-01-101465.

———. 2018c. "Prisoner-02 (version 1.0)." https://assetstore.unity.com
/packages/3d/characters/prisoner-02-107465.

Atari. 1972. *Pong*. Arcade. Atari.

———. 1977. *Combat*. Atari 2600. Atari.

———. 1982. *E.T. the Extra-Terrestrial*. Atari 2600. Atari.

Bacronym. 2020. *Airplane Mode*. PC. Bacronym. https://www.playair planemode.com/.

Barr, Pippin. 2008. "Video Game Values: Play as Human-Computer Interaction." PhD diss., Victoria University, New Zealand. https://researcharchive.vuw.ac.nz/xmlui/handle/10063/371.

———. 2011a. "Now the Artist Really Is Present." *Pippin Barr* (blog). September 14, 2011. https://pippinbarr.com/the-artist-is-present /process/process-journal.html#now-the-artist-really-is-present-2011 -09-14.

———. 2014. *Leaderboarder*. Web browser. Pippin Barr. https://pippin barr.com/leaderboarder/info/.

———. 2015a. *A Series of Gunshots*. Web browser. Pippin Barr. https:// pippinbarr.com/a-series-of-gunshots/info/.

———. 2015b. "A Series of Gunshots [HTML5, Warning: Depress-ing]." Reddit post. November 21, 2015. https://www.reddit.com/r /WebGames/comments/3tp398/a_series_of_gunshots_html5_warn ing_depressing/.

———. 2016. *It is as if you were playing chess*. Web browser. Pippin Barr. https://pippinbarr.com/it-is-as-if-you-were-playing-chess/info/.

———. 2017a. *v r 3*. PC. Pippin Barr. https://pippinbarr.com/v-r-3/info/.

———. 2017b. *Let's Play: Ancient Greek Punishment: CPU Edition*. Web browser. Pippin Barr. https://pippinbarr.com/letsplayancientgreek punishmentcpuedition/info/.

———. 2017c. *It is as if you were doing work*. Web browser. Pippin Barr. https://pippinbarr.com/itisasifyouweredoingwork/info/.

———. 2020a. "*Citizen Kane* Design Reflection." *Combat at the Movies Process Journal* (blog). June 5, 2020. https://pippinbarr.com/combat -at-the-movies/process/process-journal.html#citizen-kane-1.

———. 2020b. "Commit 5ae2559." *Combat at the Movies Git Repository* (blog). August 6, 2020. https://github.com/pippinbarr/combat-at-the -movies/commit/5ae2559b6ad6249c2a0b07eb531cbc2fc43159c2.

———. 2020c. *Combat at the Movies*. Web browser. Pippin Barr. https://pippinbarr.com/combat-at-the-movies/info/.

———. (2011) 2021. *GuruQuest*. Web browser. Pippin Barr. https://pippinbarr.com/guruquest/info/.

———. (2011) 2022a. *Let's Play: Ancient Greek Punishment*. Web browser. Pippin Barr. https://pippinbarr.com/lets-play-ancient-greek-punishment/info/.

———. (2011) 2022b. *The Artist Is Present*. Web browser. Pippin Barr. https://pippinbarr.com/the-artist-is-present/info/.

———. (2012) 2022. *PONGS*. Web browser. Pippin Barr. https://pippinbarr.com/pongs/info/.

———. 2022. *v r $4.99*. PC. Pippin Barr. https://pippinbarr.com/v-r-4-99/info/.

Barr, Pippin, and Rilla Khaled. (2015) 2022. *What We Did*. Web browser. Pippin Barr. https://pippinbarr.com/what-we-did/info/.

Beckett, Samuel. (1952) 2016. *Waiting for Godot*. London: Faber and Faber.

Bennett, John. 1996. "Reflective Conversation with Materials: An Interview with Donald Schön by John Bennett." In *Bringing Design to Software*. Edited by Terry Winograd. New York: Addison-Wesley Professional.

Black Sun. 2016. "Sahara Desert Landscape (version 1.0)." https://assetstore.unity.com/packages/3d/environments/landscapes/sahara-desert-landscape-72780.

Bogers, Dustin. 2017. "Customizable Roadside Marquee Sign (version 1.0)." https://assetstore.unity.com/packages/3d/customizable-roadside-marquee-sign-100458.

Bogost, Ian. 2012. *Alien Phenomenology, or, What It's like to Be a Thing*. Posthumanities 20. Minneapolis: University of Minnesota Press.

Bolter, Jay David, and Richard Grusin. 2003. *Remediation: Understanding New Media*. 6th ed. Cambridge, MA: MIT Press.

Brady, Andrew, and Garry Prentice. 2021. "Are Loot Boxes Addictive? Analyzing Participant's Physiological Arousal While Opening a Loot Box." *Games and Culture* 16, no. 4 (June): 419–433. https://doi.org/10.1177/1555412019895359.

Bresson, Robert, dir. 1966. *Au Hasard Balthazar*. Athos Films.

Brough, Michael. 2012. *VESPER.5*. Web browser. Michael Brough. http://mightyvision.blogspot.com/2012/08/vesper5.html.

Bugrimov, Maksim. 2020. "Humanoid Creatures Pack (version 1.1)." https://assetstore.unity.com/packages/3d/characters/creatures/human oid-creatures-pack-162689.

Burns, Anna. 2019. *Milkman*. Minneapolis: Graywolf Press.

Caillois, Roger. (1961) 2001. *Man, Play, and Games.* Translated by Meyer Barash. Urbana: University of Illinois Press.

Camus, Albert. 1991. *The Myth of Sisyphus and Other Essays*. 1st Vintage international ed. Translated by Justin O'Brien. New York: Vintage Books.

Chang, Alenda Y. 2019. "Between Plants and Polygons: SpeedTrees and an Even Speedier History of Digital Morphogenesis." *Electronic Book Review*. December 15, 2019. https://doi.org/10.7273/WTDF-7W30.

Coppola, Francis Ford, dir. 1972. *The Godfather*. Paramount Pictures.

———. 1974. *The Conversation*. Paramount Pictures.

Crawford, Chris. 2003. *Chris Crawford on Game Design*. Indianapolis: New Riders.

Curtis, Adam, dir. 2011. *All Watched Over by Machines of Loving Grace*. BBC.

Custodio, Alex. 2020. *Who Are You? Nintendo's Game Boy Advance Platform*. Platform Studies. Cambridge, MA: MIT Press.

DeKoven, Bernie. (1978) 2013. *The Well-Played Game: A Player's Philosophy*. Cambridge, MA: MIT Press.

Denis, Claire, dir. 1999. *Beau Travail*. Pyramide Distribution.

Dogmatic. 2016. "AQUAS Water LITE." Digital water. https://asset store.unity.com/packages/vfx/shaders/aquas-lite-built-in-render-pipe-line-53519

Dovey, Jon, and Helen W. Kennedy. 2006. *Game Cultures: Computer Games as New Media*. Issues in Cultural and Media Studies. Maidenhead, Berkshire, UK: Open University Press.

Ebert, Roger. 2010. "Video Games Can Never Be Art." *Roger Ebert* (blog). April 16, 2010. https://www.rogerebert.com/roger-ebert/video -games-can-never-be-art.

Fassone, Riccardo. 2020. "Notoriously Bad: Early Film-to-Video Game Adaptations (1982–1994)." In *The Routledge Companion to Adaptation*. Edited by Dennis Ray Cutchins, Katja Krebs, and Eckart Voigts-Virchow. Routledge Companions. London: Routledge, Taylor & Francis group.

Flanagan, Mary. 2009. *Critical Play: Radical Game Design*. Cambridge, MA: MIT Press.

Fogg, B. J. 2003. *Persuasive Technology: Using Computers to Change What We Think and Do*. The Morgan Kaufmann Series in Interactive Technologies. Amsterdam: Morgan Kaufmann Publishers.

Fullerton, Tracy, Christopher Swain, and Steven Hoffman. 2008. *Game Design Workshop: A Playcentric Approach to Creating Innovative Games*. 2nd ed. Amsterdam: Elsevier Morgan Kaufmann.

Gaddis, William. (1975) 2012. *JR*. 1st ed. Champaign, IL: Dalkey Archive Press.

GBAndrewGB. 2018. "Voxel Animals (#23)." https://assetstore.unity.com/packages/3d/characters/animals/voxel-animals-23-130937.

Gowanlock, Jordan. 2021. *Animating Unpredictable Effects: Nonlinearity in Hollywood's R&D Complex*. Palgrave Animation. Uxbridge, UK: Palgrave Macmillan Cham.

Graeber, David. 2019. *Bullshit Jobs*. New York: Simon & Schuster.

Hanson, Christopher. 2018. *Game Time: Understanding Temporality in Video Games*. Digital Game Studies. Bloomington: Indiana University Press.

Hutcheon, Linda. 2012. *A Theory of Adaptation*. 2nd ed. London: Routledge. https://doi.org/10.4324/9780203095010.

IL.ranch. 2020. "*Cyberpunk—Cyber Room* (version 1.0)." https://assetstore.unity.com/packages/3d/environments/sci-fi/cyberpunk-cyber-room-169139.

janpec. 2019. "*Animal Pack Deluxe V2* (version 1.0)." https://assetstore.unity.com/packages/3d/characters/animals/animal-pack-deluxe-v2-144071.

Jenkins, Henry. 2006. "The War Between Effects and Meaning: Rethinking the Video Game Violence Debate." In *Digital Generations: Children, Young People, and the New Media*. Edited By David Buckingham and Rebekah Willett. New York: Routledge.

Jonze, Spike, dir. 2002. *Adaptation*. Sony Pictures.

Judd, Donald. 1982. *100 Untitled Works in Mill Aluminum*. Sculpture.

Juul, Jesper. 2017. "Interview with David Kanaga." *Jesper Juul* (blog). September 19, 2017. https://www.jesperjuul.net/handmadepixels/inter views/kanaga.html.

Kanaga, David. 2017. *Oikospiel Book 1*. http://www.oikospiel.com/.

Kazemi, Darius. 2014. "Corpora." Repository. https://github.com/dar iusk/corpora/.

Keogh, Brendan. 2013a. "When Game Over Means Game Over: Using Permanent Death to Craft Living Stories in *Minecraft*." In *Proceedings of the 9th Australasian Conference on Interactive Entertainment Matters of Life and Death—IE '13*. Melbourne: ACM Press. https://doi .org/10.1145/2513002.2513572.

———. 2013b. *Killing Is Harmless: A Critical Reading of Spec Ops: The Line*. 1st edition. Adelaide: Stolen Projects.

Khaled, Rilla, and Pippin Barr. 2023. "Generative Logics and Conceptual Clicks: A Case Study of the Method for Design Materialization." *Design Issues* 39, no. 1 (January 2023): 55–69. https://doi.org/10.1162/ desi_a_00706.

Khaled, Rilla, Jonathan Lessard, and Pippin Barr. 2018. "Documenting Trajectories in Design Space: A Methodology for Applied Game Design Research." In *Proceedings of the 13th International Conference on the Foundations of Digital Games*. Malmö: ACM. https://doi .org/10.1145/3235765.3235767.

Kiciński, Adam. 2021. "CD PROJEKT Group annual results 2020." Teleconference transcript. https://www.cdprojekt.com/en/wp-content /uploads-en/2021/04/transcript-2020-results.pdf.

Kubrick, Stanley, dir. 1968. *2001: A Space Odyssey*. Metro-Goldwyn-Mayer.

Kurosawa, Akira, dir. 1950. *Rashomon*. Daiei.

Manovich, Lev. 2013. *Software Takes Command: Extending the Language of New Media*. International Texts in Critical Media Aesthetics. New York: Bloomsbury.

McLuhan, Marshall. 1994. *Understanding Media: The Extensions of Man*. 1st MIT Press ed. Cambridge, MA: MIT Press.

Miller, Daniel. 2010. *Stuff*. Cambridge: Polity Press.

Molleindustria. 2016. "Low Poly Water." Digital water. Personal correspondence.

Montfort, Nick, Patsy Baudoin, John Bell, Ian Bogost, Jeremy Douglass, Mark C. Marino, Michael Mateas, Casey Reas, Mark Sample, and Noah Vawter. 2014. *10 PRINT CHR$(205.5+RND(1));:GOTO 10*. Software Studies. Cambridge, MA: MIT Press.

Montfort, Nick, and Ian Bogost. 2009. *Racing the Beam: The Atari Video Computer System*. Platform Studies. Cambridge, MA: MIT Press.

Morawe, Volker, and Tilman Reiff. 2001. *PainStation 1—Enhanced Duelling Artefact*. ///////////fur//// art entertainment interfaces. https://www.fursr.com/projects/painstation.

Nicoll, Benjamin, and Brendan Keogh. 2019a. "Grain: Default Settings, Design Principles, and the Aura of Videogame Production." In *The Unity Game Engine and the Circuits of Cultural Software*, by Benjamin Nicoll and Brendan Keogh. London: Palgrave Pivot. https://doi.org/10.1007/978-3-030-25012-6_4.

———. 2019b. *The Unity Game Engine and the Circuits of Cultural Software*. London: Palgrave Pivot. Cham, Switzerland: Palgrave Macmillan.

Nielsen, Jakob. 1994. "10 Usability Heuristics for User Interface Design." *Nielsen Norman Group* (blog). April 24, 1994. https://www.nngroup.com/articles/ten-usability-heuristics/.

Nintendo. 2003–2021. *WarioWare*. Series. Nintendo.

Openlab. 2020. "Egypt Pack—Spider (version 1.0)." https://assetstore.unity.com/packages/3d/characters/animals/insects/egypt-pack-spider-122734.

Oppenheimer, Joshua, dir. 2012. *The Act of Killing*. Dogwoof.

Ozu, Yasujirō, dir. 1953. *Tokyo Story*. Shochiku.

Paul, Christopher A. 2020. *Free-to-Play: Mobile Video Games, Bias, and Norms*. Cambridge, MA: MIT Press.

Peel, Jeremy. 2014. "GlitchHiker: The Game That Was Programmed to Die." *PCGamesN* (blog). October 9, 2014. https://www.pcgamesn.com/indie/glitchhiker-game-was-programmed-die.

Phillips, Amanda. 2018. "Shooting to Kill: Headshots, Twitch Reflexes, and the Mechropolitics of Video Games." *Games and Culture* 13, no. 2 (March): 136–152. https://doi.org/10.1177/1555412015612611.

Playtika. 2011. *Slotomania*. iOS. Playtika.

Pope, Lucas. 2013. *Papers, Please*. PC. 3909 LLC. https://papersplea.se/.

Przybylski, Andrew K., and Netta Weinstein. 2019. "Violent Video Game Engagement Is Not Associated with Adolescents' Aggressive Behaviour: Evidence from a Registered Report." *Royal Society Open Science* 6, no. 2: 171474. https://doi.org/10.1098/rsos.171474.

Queneau, Raymond. (1982) 2013. *Exercises in Style*. Translated by Barbara Wright. New York: New Directions.

Remedy Entertainment. 2010. *Alan Wake*. Remedy Entertainment.

Ruberg, Bonnie. 2020. *The Queer Games Avant-Garde: How LBGTQ Game Makers Are Reimagining the Medium of Video Games*. Durham: Duke University Press.

Rudin, David. 2015. "A Series of Gunshots Calls Out Senseless Gun Violence in Games." *Killscreen* (blog). November 19, 2015. https://killscreen.com/previously/articles/a-series-of-gunshots-calls-out-senseless-gun-violence-in-games/.

Ryerson, Liz. 2013. *Problem Attic*. Web browser. Liz Ryerson. https://lizryerson.itch.io/problem-attic.

s0lly. 2019. *[CELL]IVIZATION*. Web browser. s0lly. https://s0lly.itch.io/cellivization.

Schön, Donald A. 1983. *The Reflective Practitioner: How Professionals Think in Action*. New York: Basic Books.

Schön, Donald A. 1992. "Designing as Reflective Conversation with the Materials of a Design Situation." *Research in Engineering Design* 3 (September): 131–147. https://doi.org/10.1007/BF01580516.

Schüll, Natasha Dow. 2014. *Addiction by Design: Machine Gambling in Las Vegas*. Princeton: Princeton University Press.

Scorsese, Martin, dir. 1976. *Taxi Driver*. Columbia Pictures.

Seller, Merlin. 2020. "Vegetal Horrors: Blair Witch, Darkwood and Non-Human Turn Game Studies." In *DiGRA '20—Proceedings of the 2020 DiGRA International Conference: Play Everywhere*. Digital Games Research Association. http://www.digra.org/digital-library/publica

tions/vegetal-horrors-blair-witch-darkwood-and-non-human-turn
-game-studies/.

Sharp, John. 2015. *Works of Game: On the Aesthetics of Games and Art.* Playful Thinking. Cambridge, MA: MIT Press.

Shklovsky, Viktor. (1917) 2015. "Art, as Device." Translated by Alexandra Berlina. *Poetics Today* 36, no. 3 (September): 151–174. https://doi.org/10.1215/03335372-3160709.

Soderman, Braxton. 2021. *Against Flow: Video Games and the Flowing Subject.* Cambridge, MA: MIT Press.

Spielberg, Steven, dir. 1982. *E.T. the Extra-Terrestrial.* Universal Pictures.

Suko, Junnichi. 2018. "Seagull (Larus canus) (version 1.0)." https://assetstore.unity.com/packages/3d/characters/animals/birds/seagull-larus-canus-109558.

Tanizaki, Jun'ichirō. (1933) 2008. *In Praise of Shadows.* Translated by Thomas J. Harper and Edward Seidensticker. Sedgwick, ME: Leete's Island Books.

Tarkovsky, Andrey. 2005. *Sculpting in Time: Reflections on the Cinema.* Translated by Kitty Hunter-Blair. Austin: University of Texas Press.

Tarr, Béla, dir. (1994) 2019. *Sátántangó.* Arbelos Films.

Tati, Jacques, dir. 1967. *Playtime.*

Team G. E. Dev. 2017. "Water Flow FREE." Digital water. https://assetstore.unity.com/packages/vfx/shaders/water-flow-free-26434

Teikari, Arvi. 2019. *Baba Is You.* PC. Arvi Teikari.

TheLaba. 2018. "Low Poly Rigged Animals (version 2.0)." https://assetstore.unity.com/packages/3d/characters/animals/low-poly-rigged-animals-123656.

TI Games. 2015. "Procedure Water." Digital water. https://assetstore.unity.com/packages/vfx/shaders/procedure-water-26634.

Truffaut, François. 1984. *Hitchcock: The Definitive Study of Alfred Hitchcock.* Translated by Helen G. Scott. Rev. ed. New York: Simon & Schuster.

Tsai, Ming-liang, dir. 2014. *Stray Dogs.* Cinema Guild.

Tufte, Edward R. 2004. *The Cognitive Style of PowerPoint.* Cheshire, CT: Graphics Press.

Vinterberg, Thomas, dir. 1998. *Festen* [*The Celebration*]. Nimbus Film.

Weizenbaum, Joseph. 1966. "ELIZA—a Computer Program for the Study of Natural Language Communication between Man and Machine." *Communications of the ACM* 9, no. 1 (January): 36–45. https://doi.org/10.1145/365153.365168.

Welles, Orson, dir. 1941. *Citizen Kane*. RKO Radio Pictures.

Werning, Stefan. 2021. *Making Games: The Politics and Poetics of Game Creation Tools*. Playful Thinking. Cambridge, MA: MIT Press.

Yang, Robert. 2015. "Decent Water." Digital water. Personal correspondence.

Zachtronics. 2016. *Shenzhen I/O*. PC. Zachtronics.

Zahedi, Caveh, dir. 2015. *The Show About the Show*. Web Series. BRIC TV.

ZA/UM. 2019. *Disco Elysium*. PC. ZA/UM.

INDEX